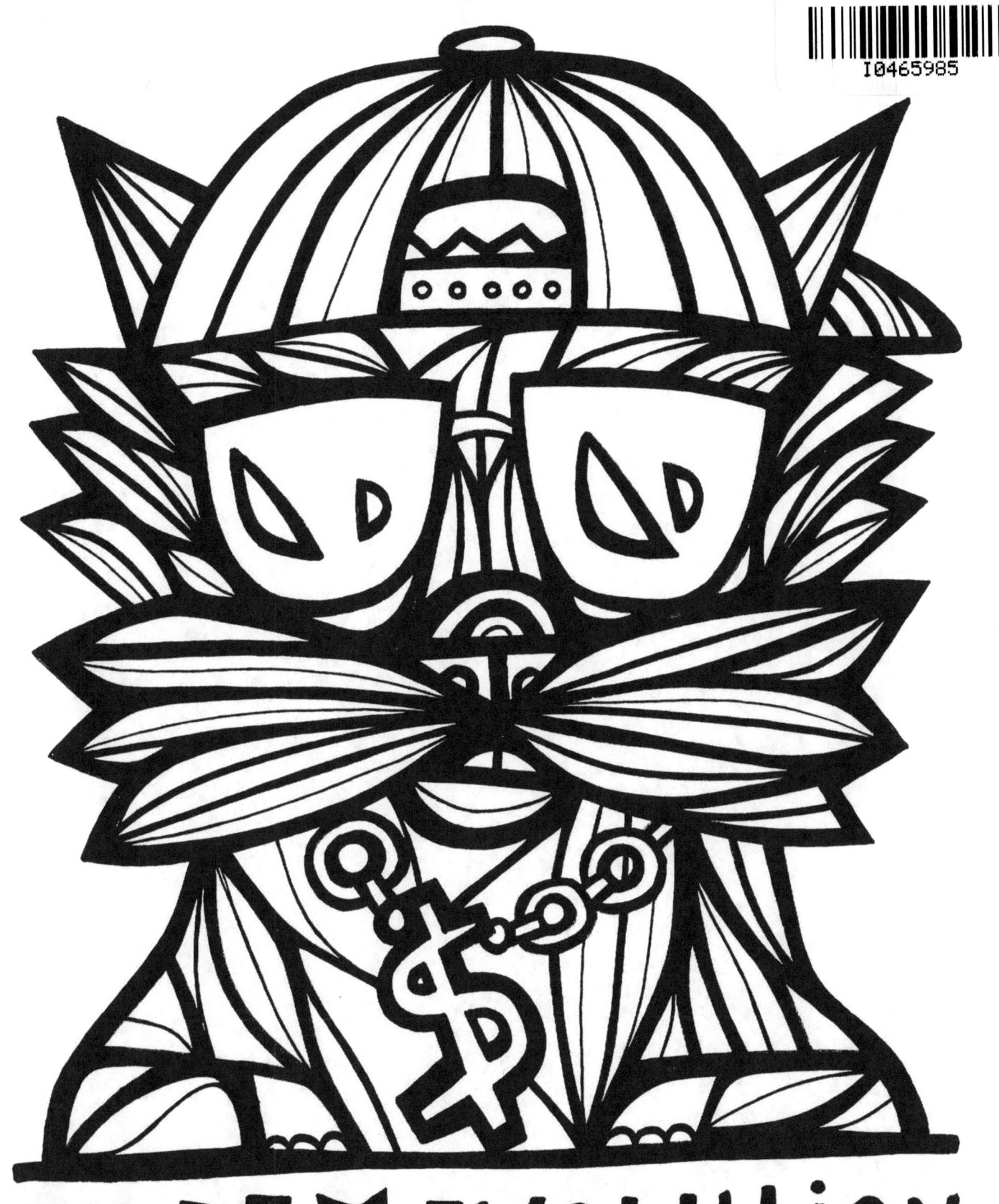

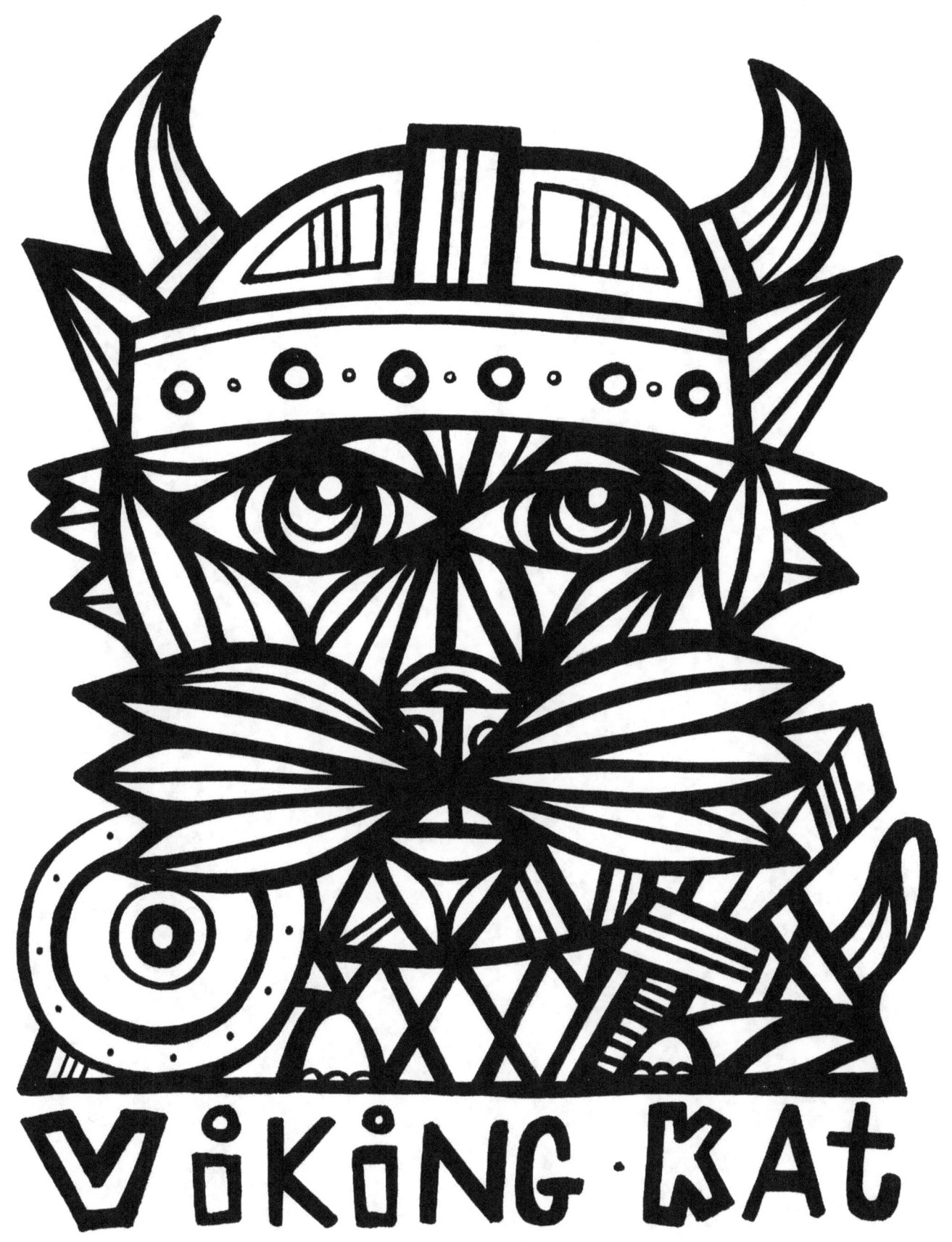

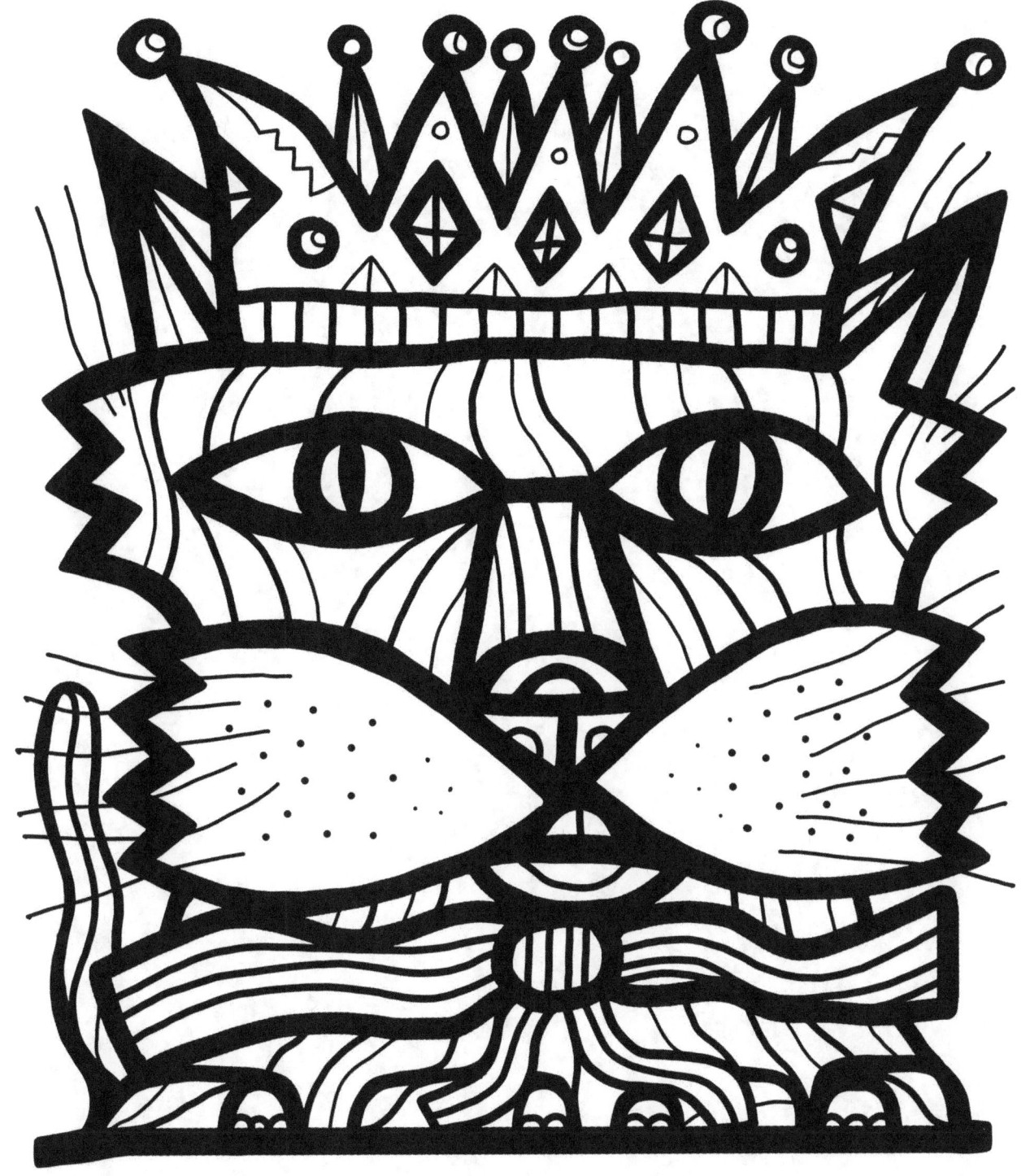

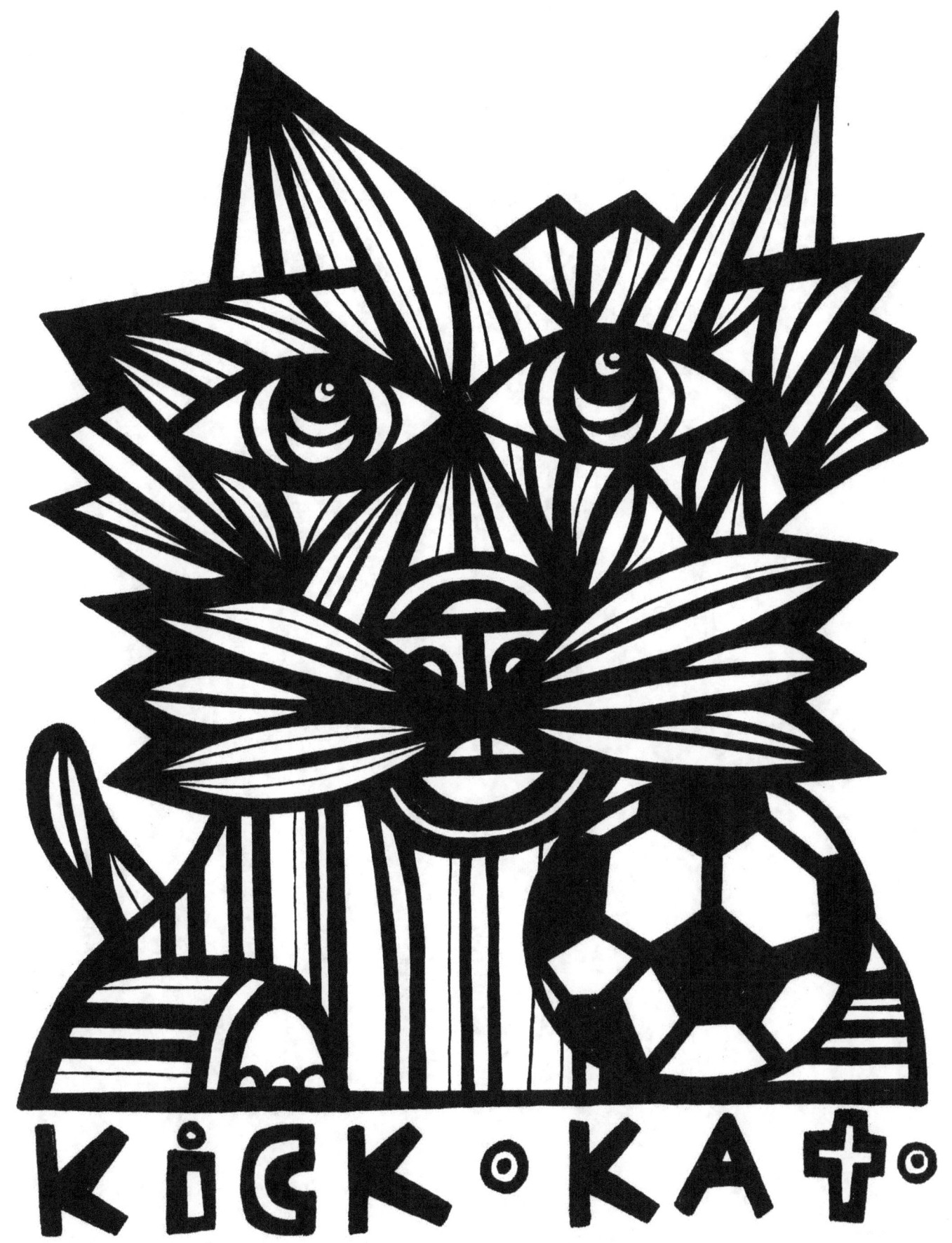

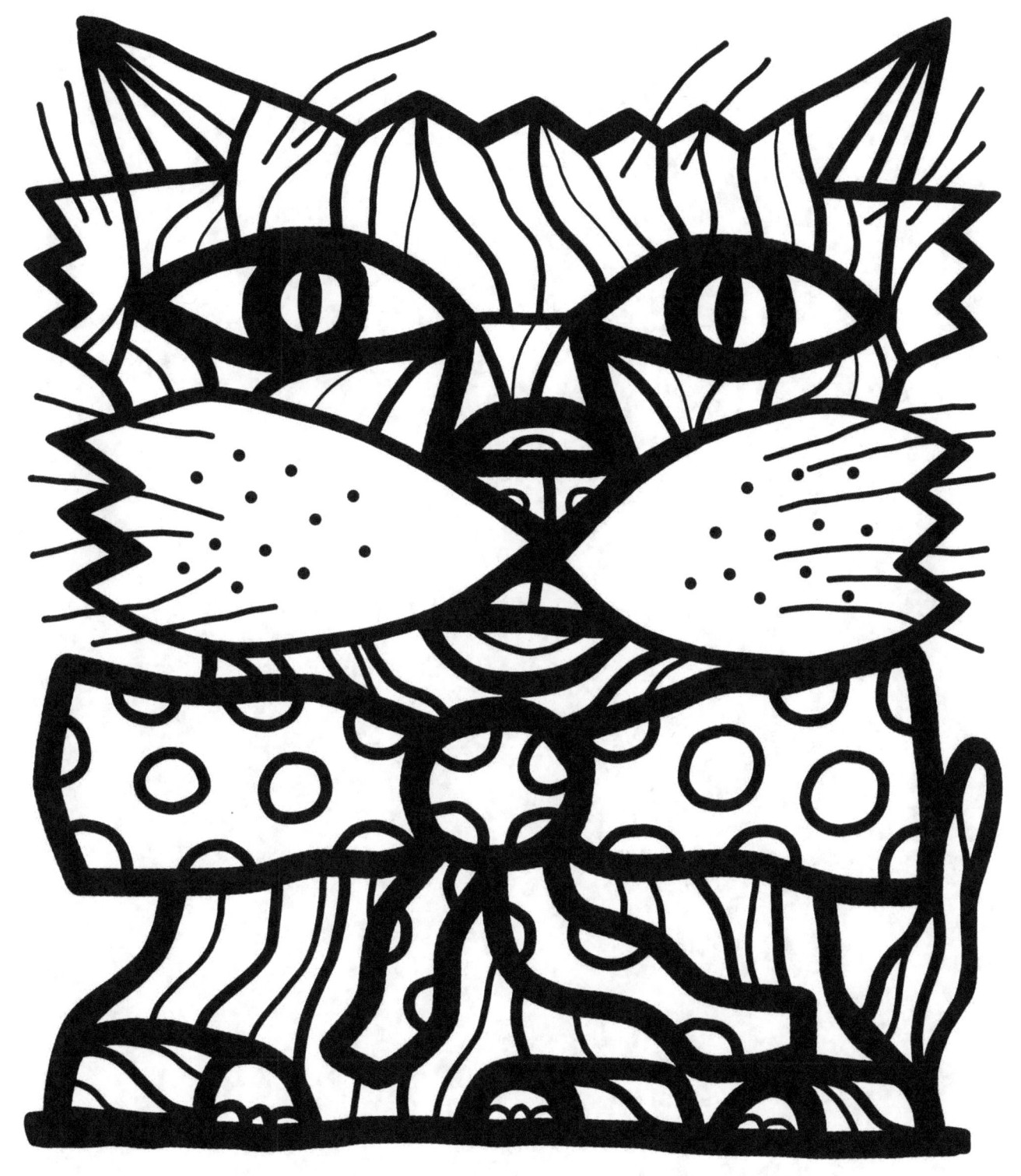

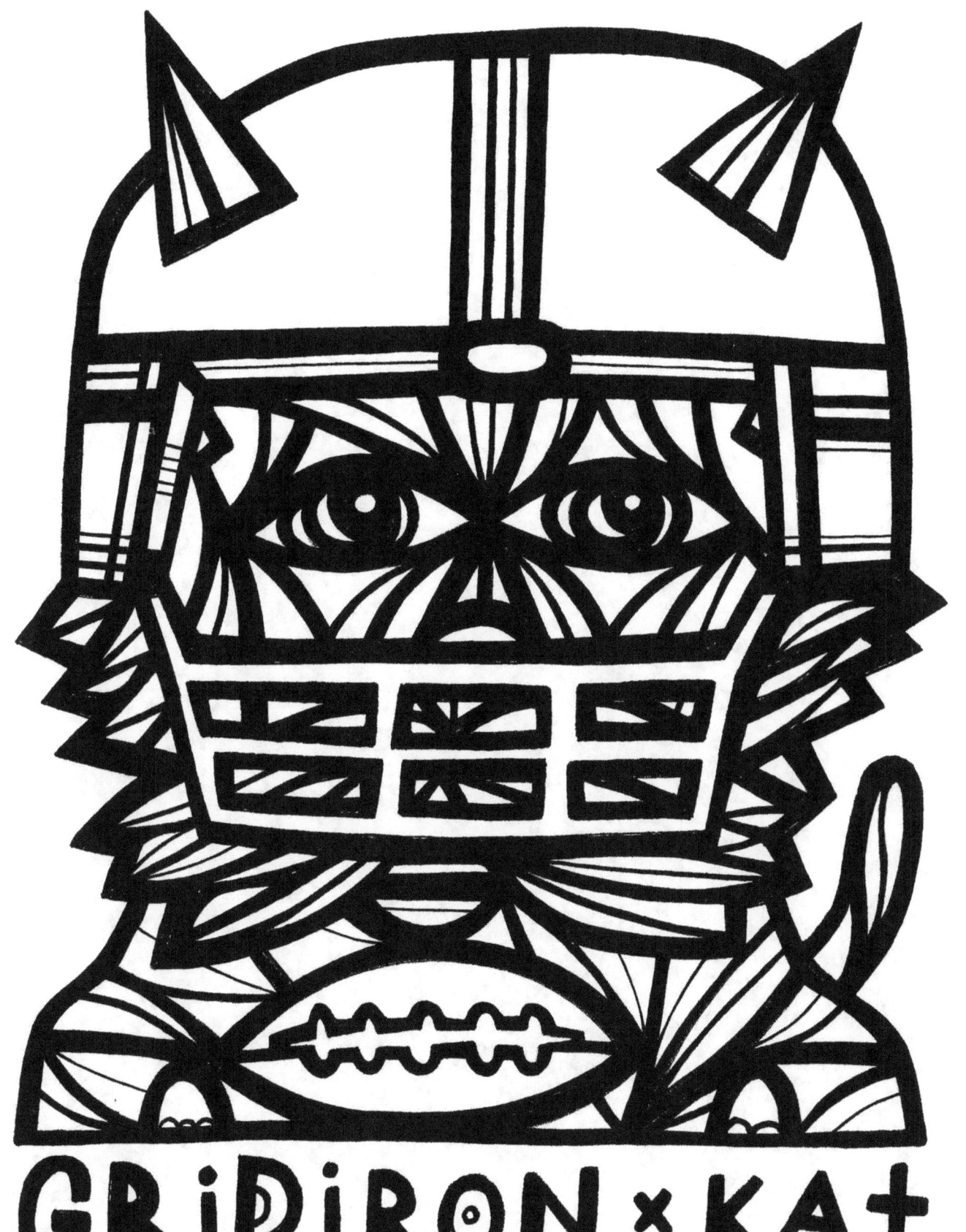

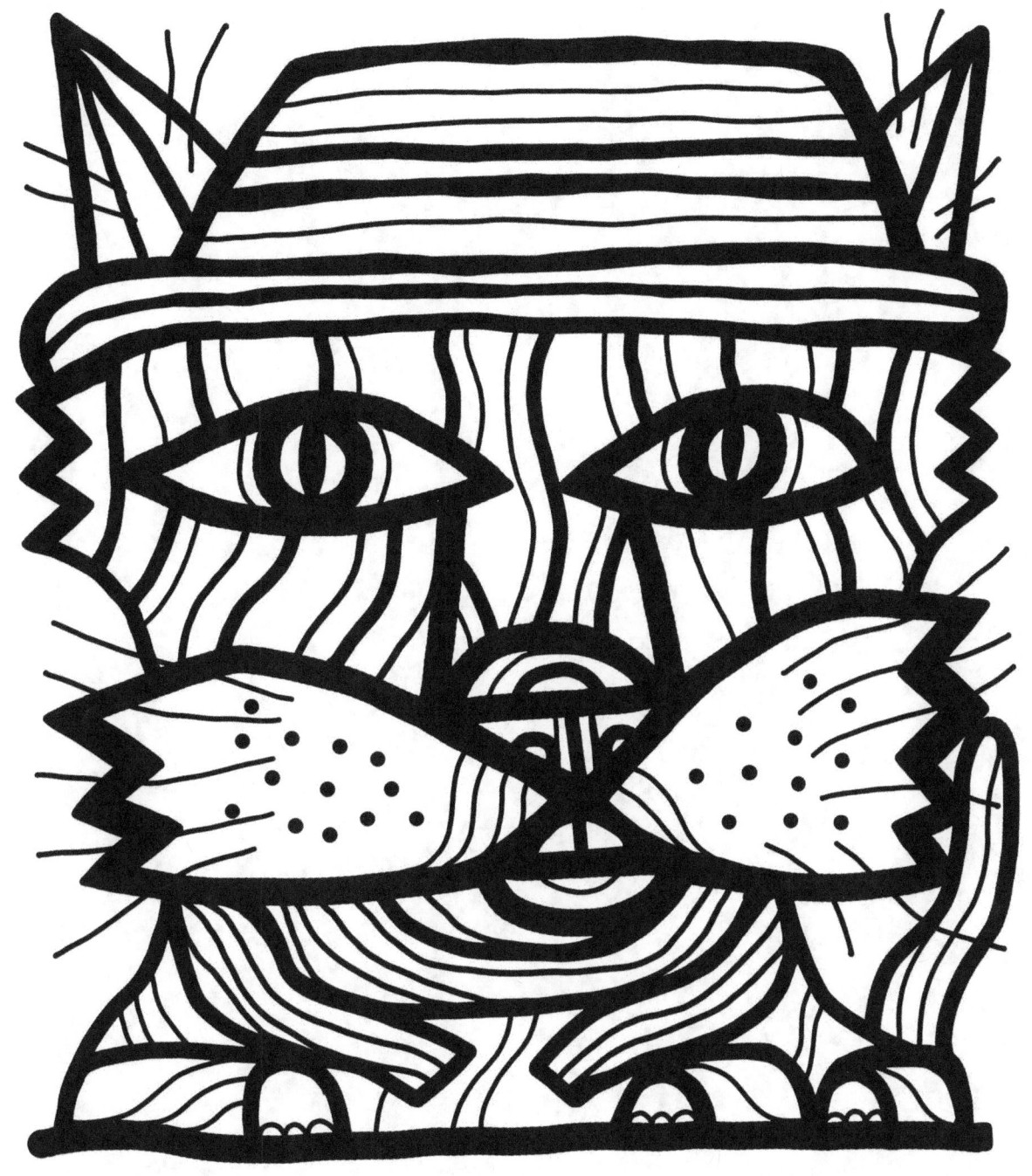

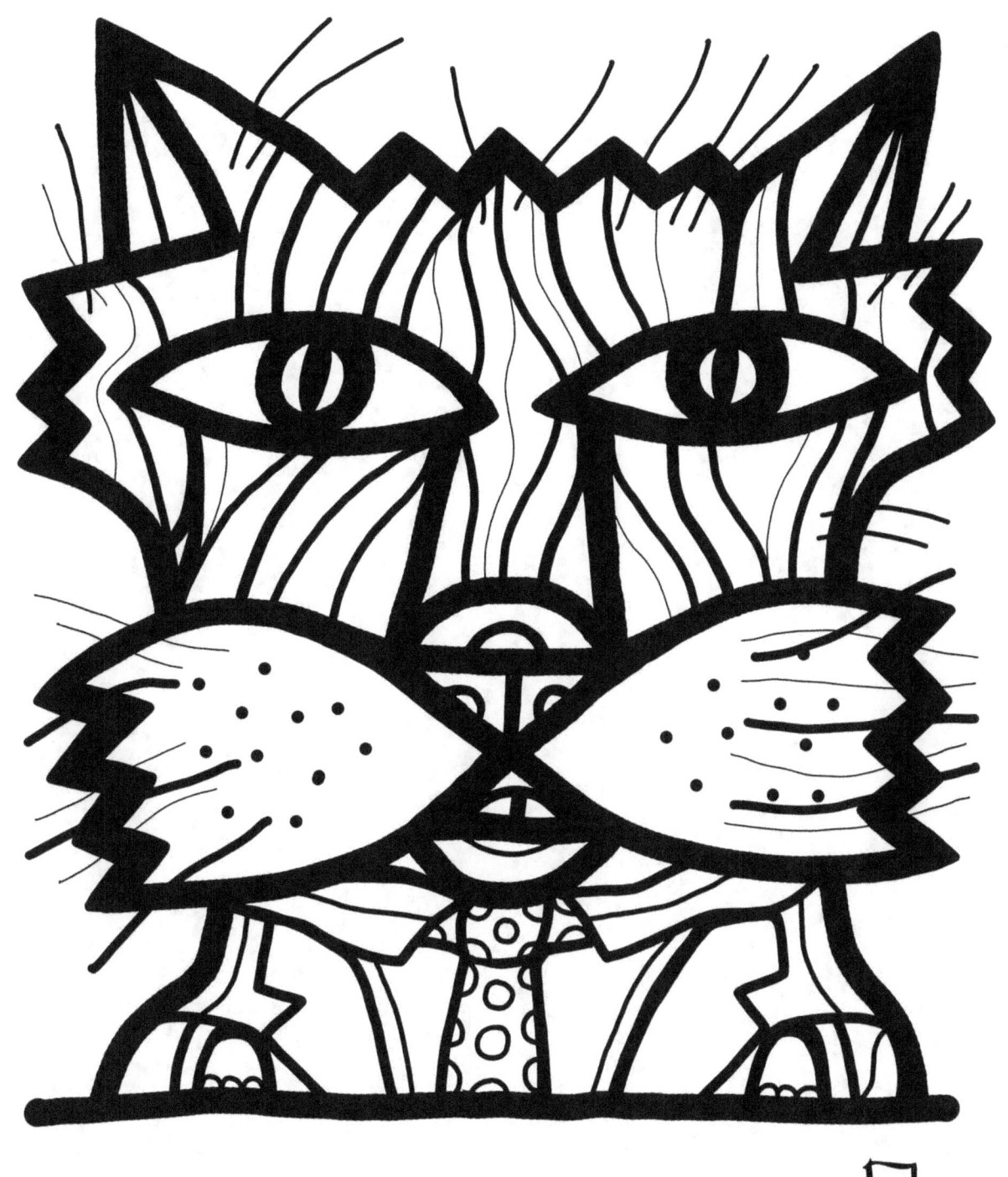

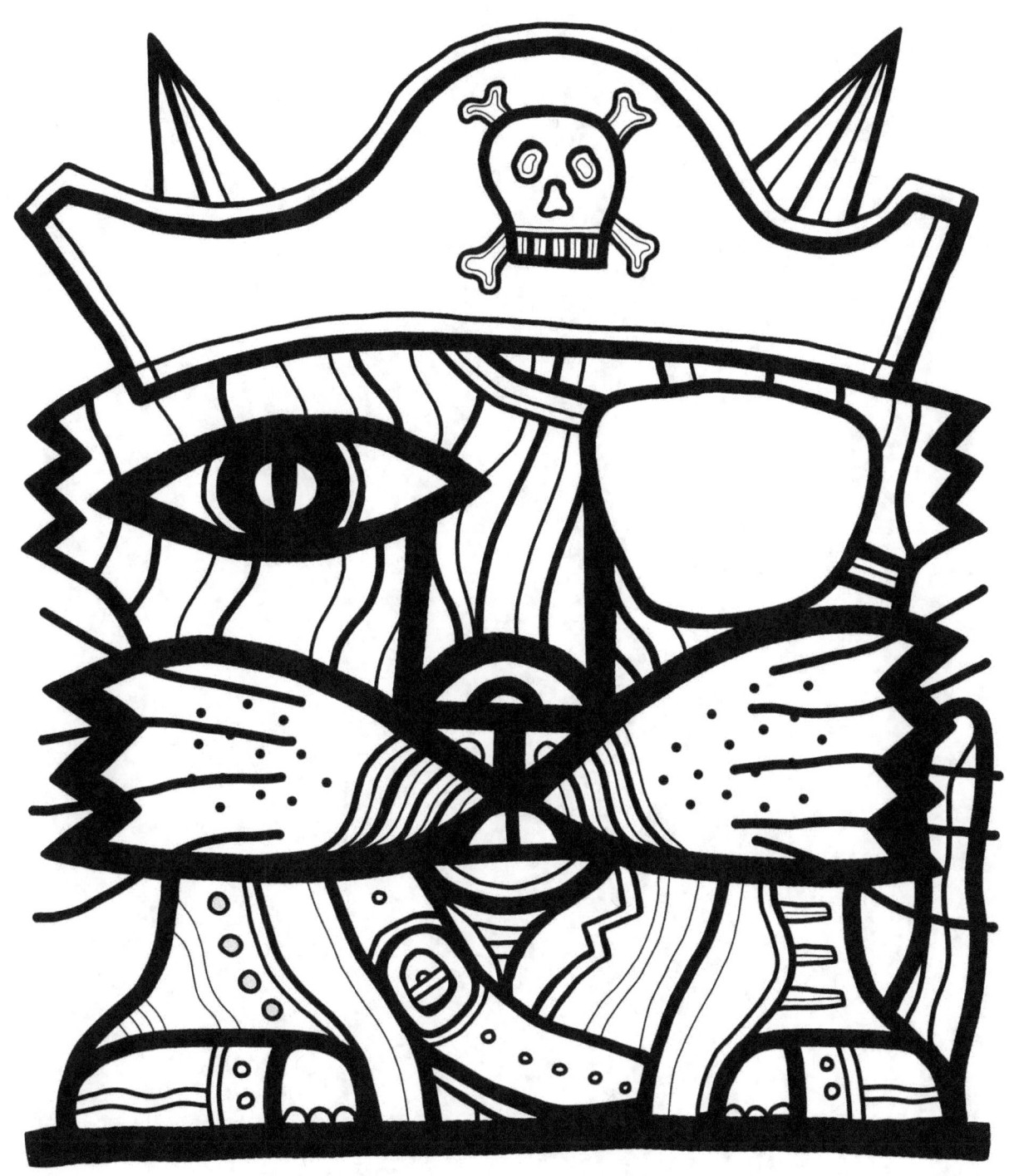

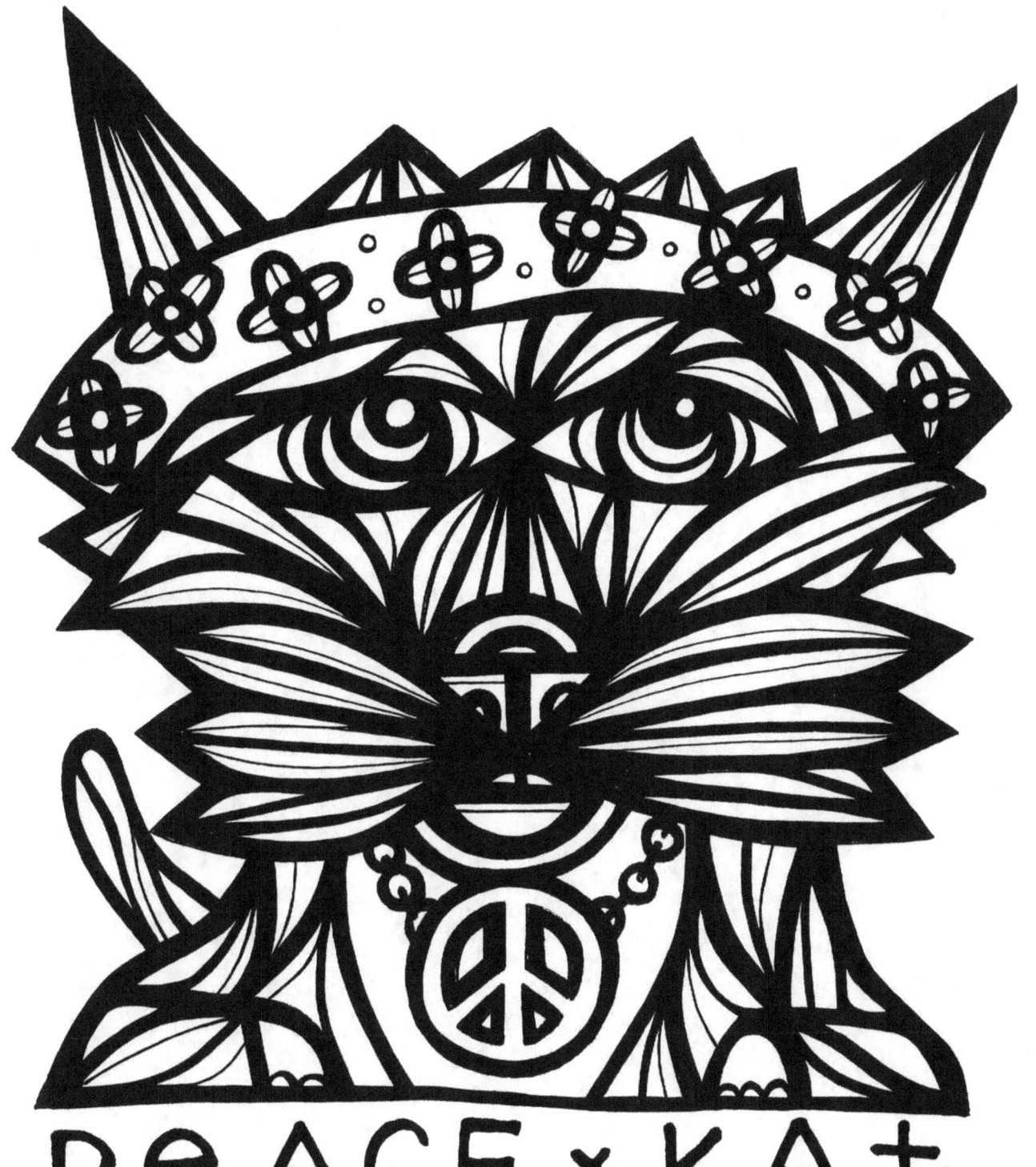

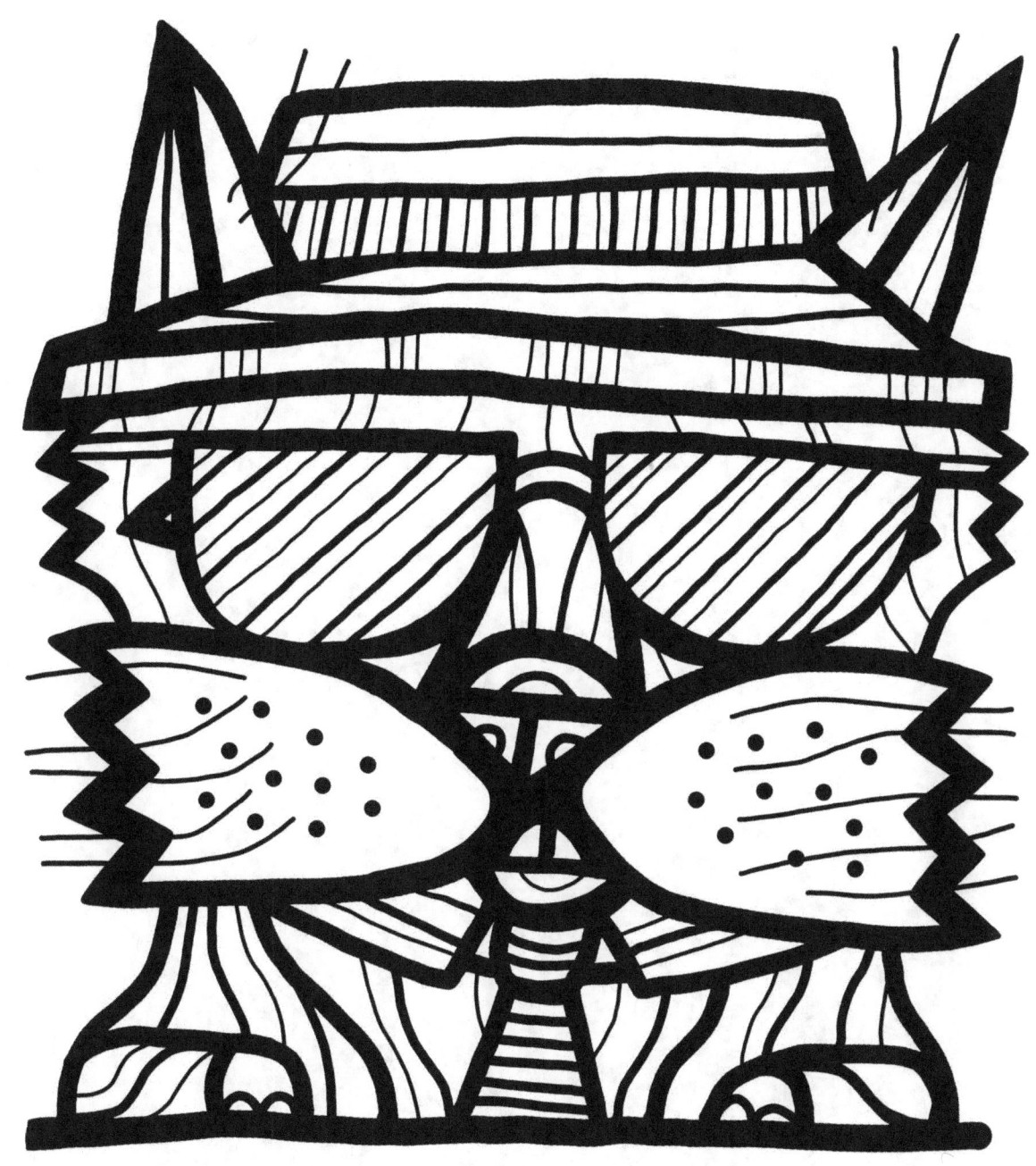

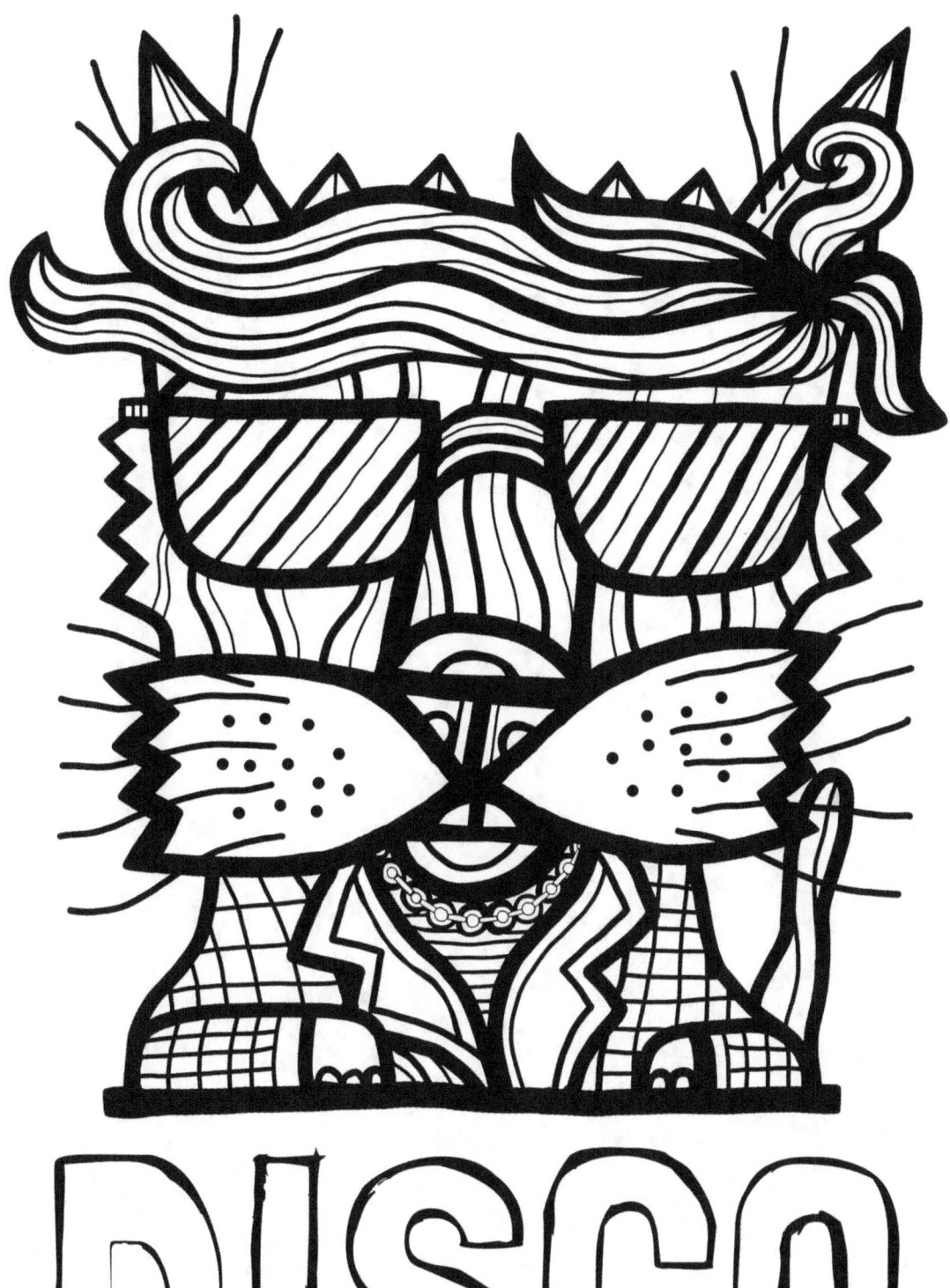

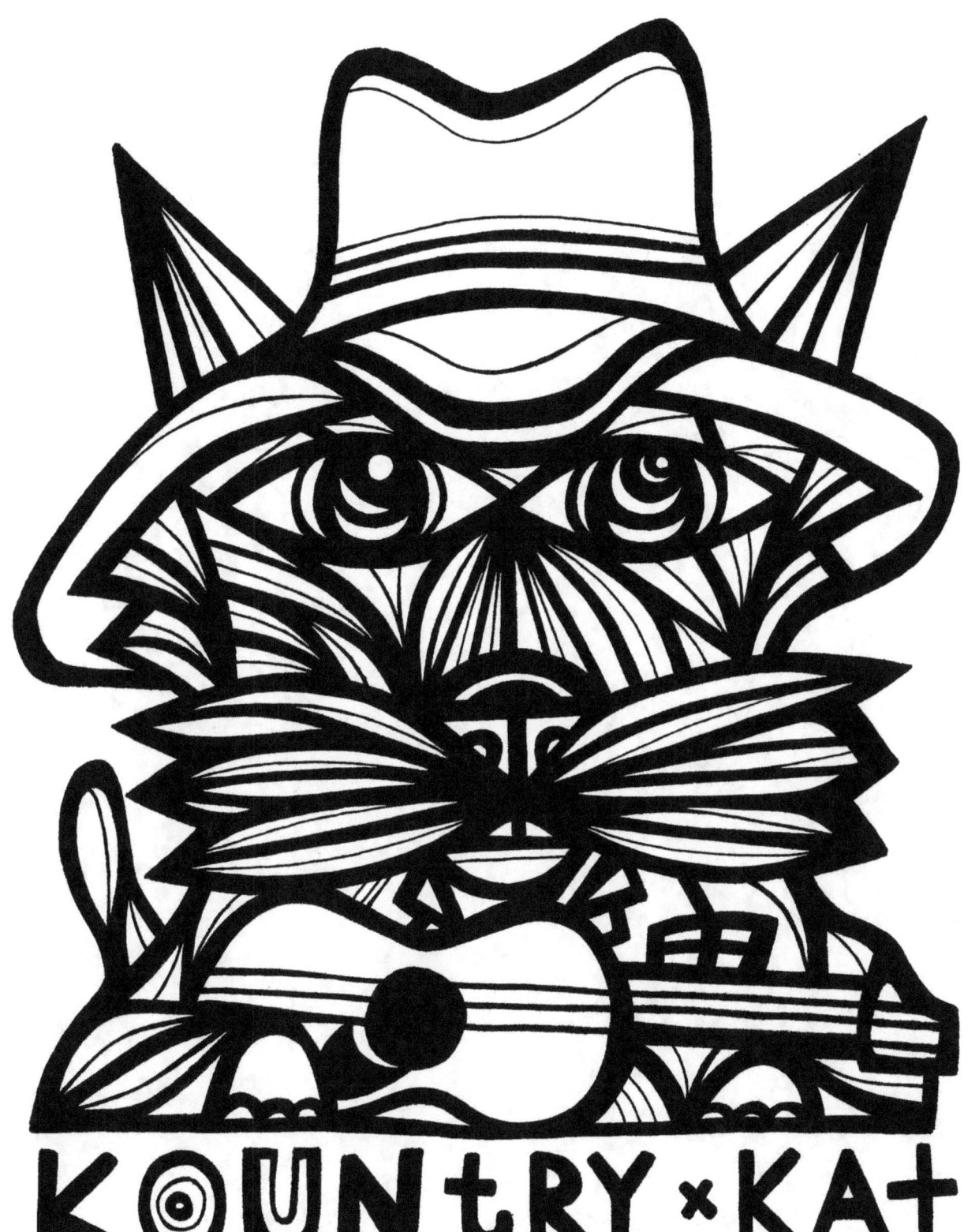

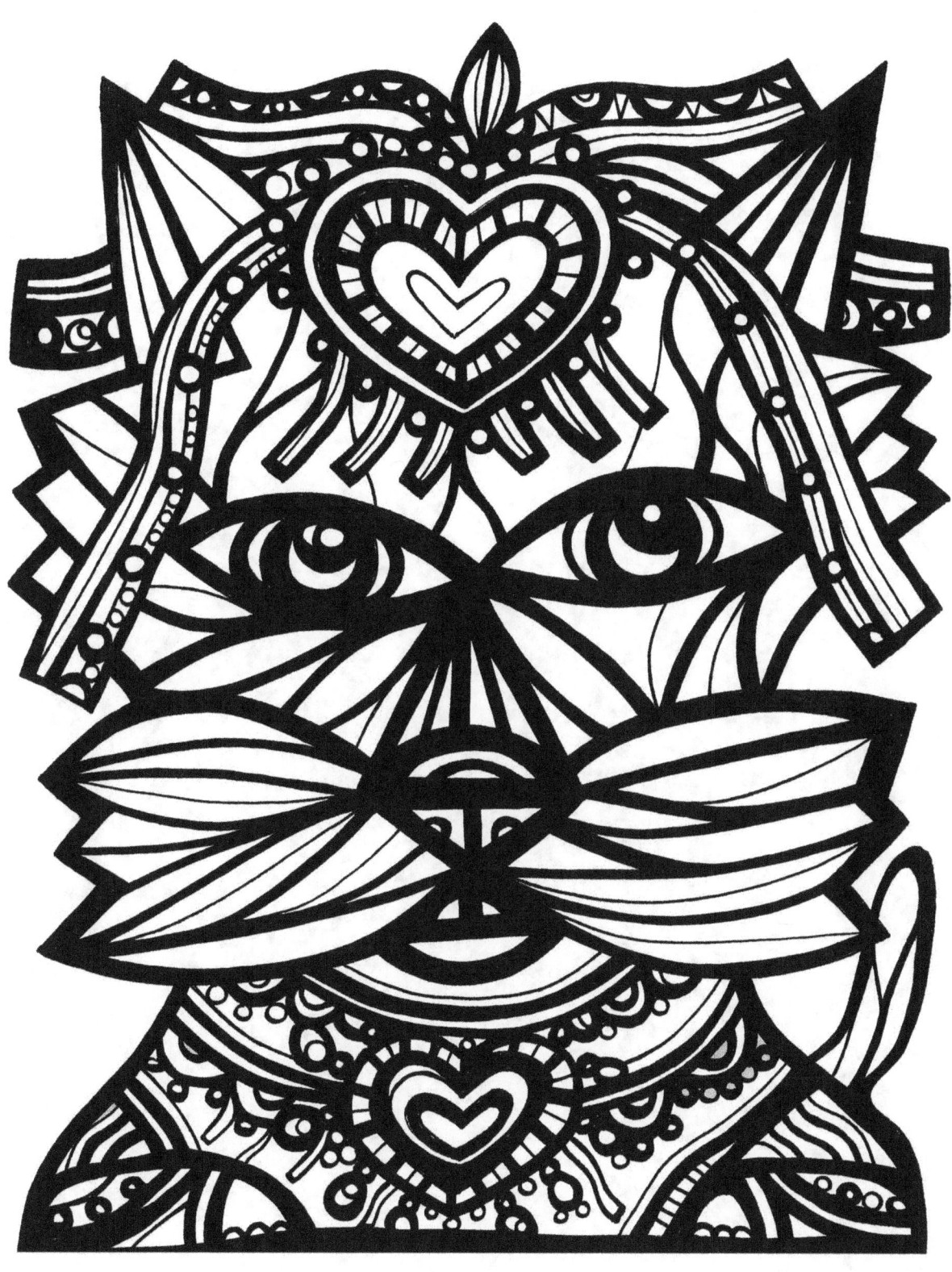

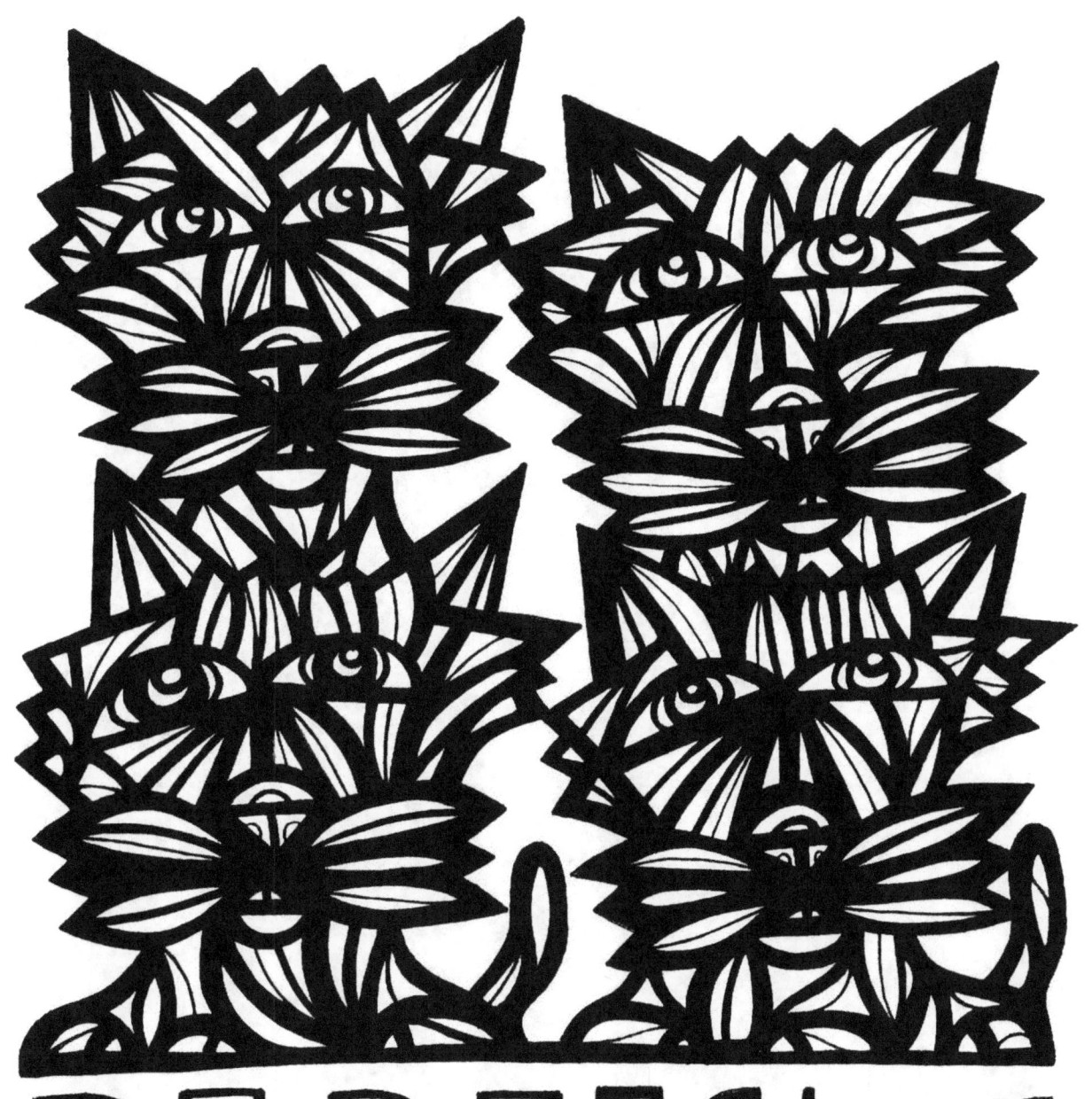

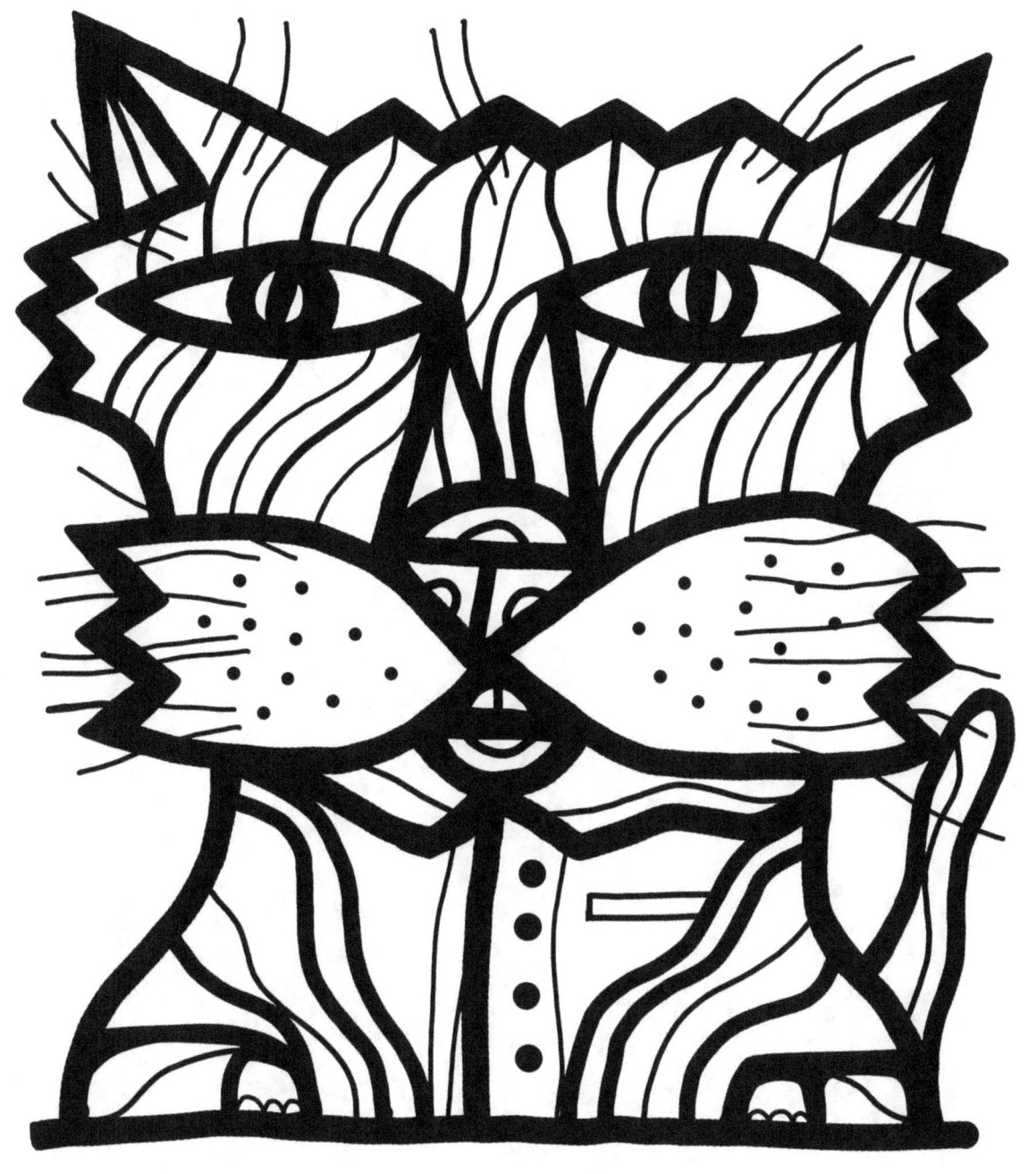

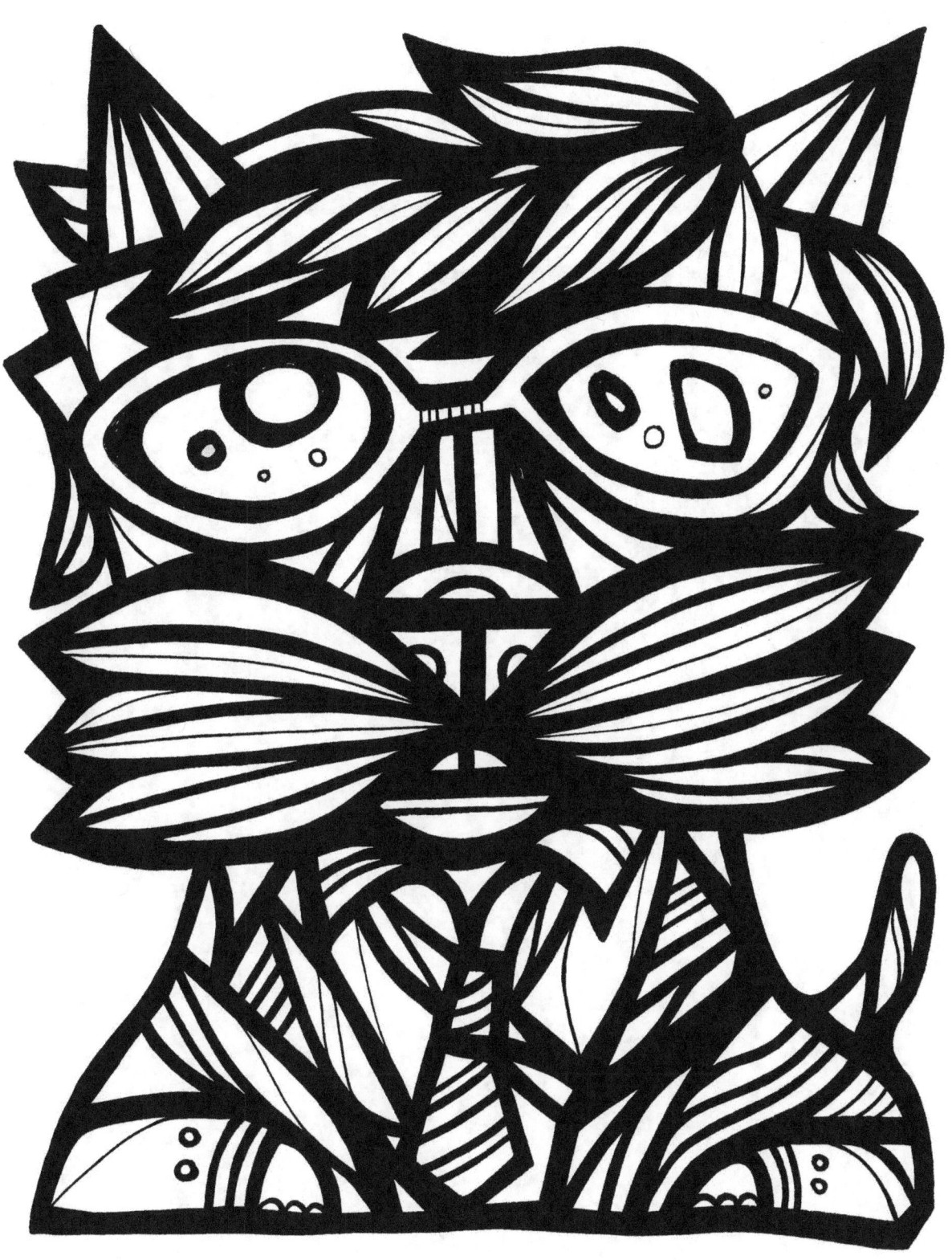

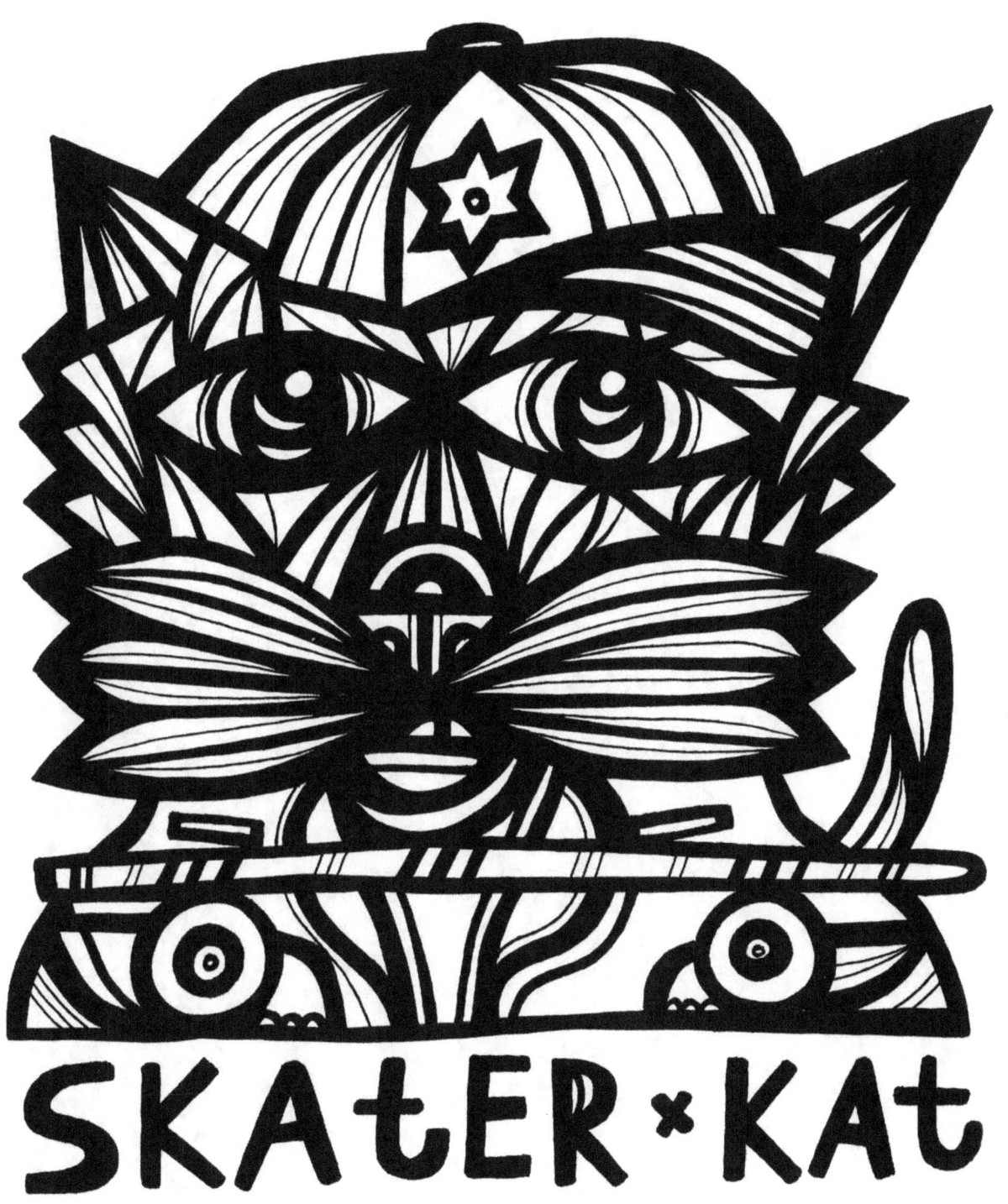

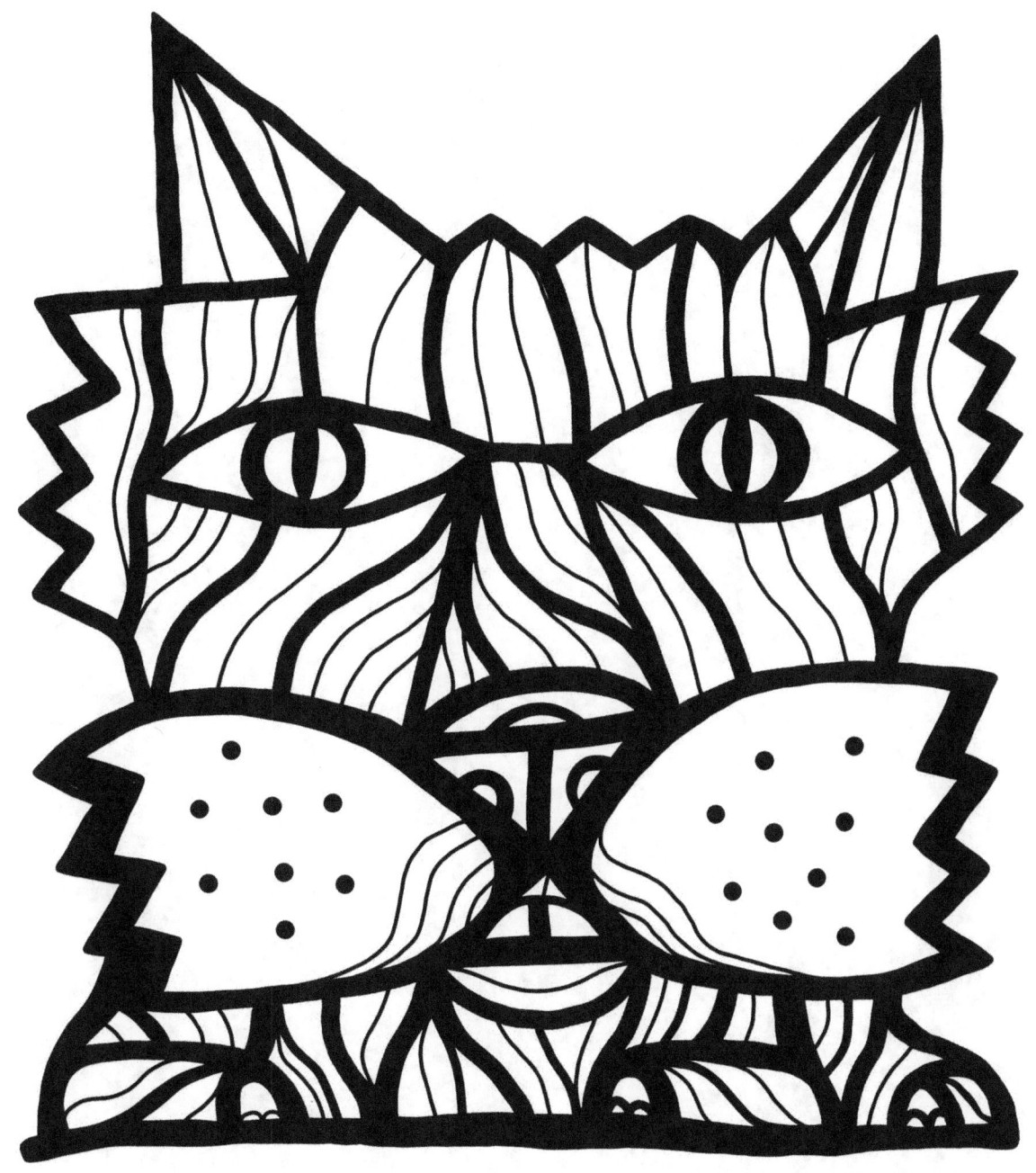

Give more hugs.

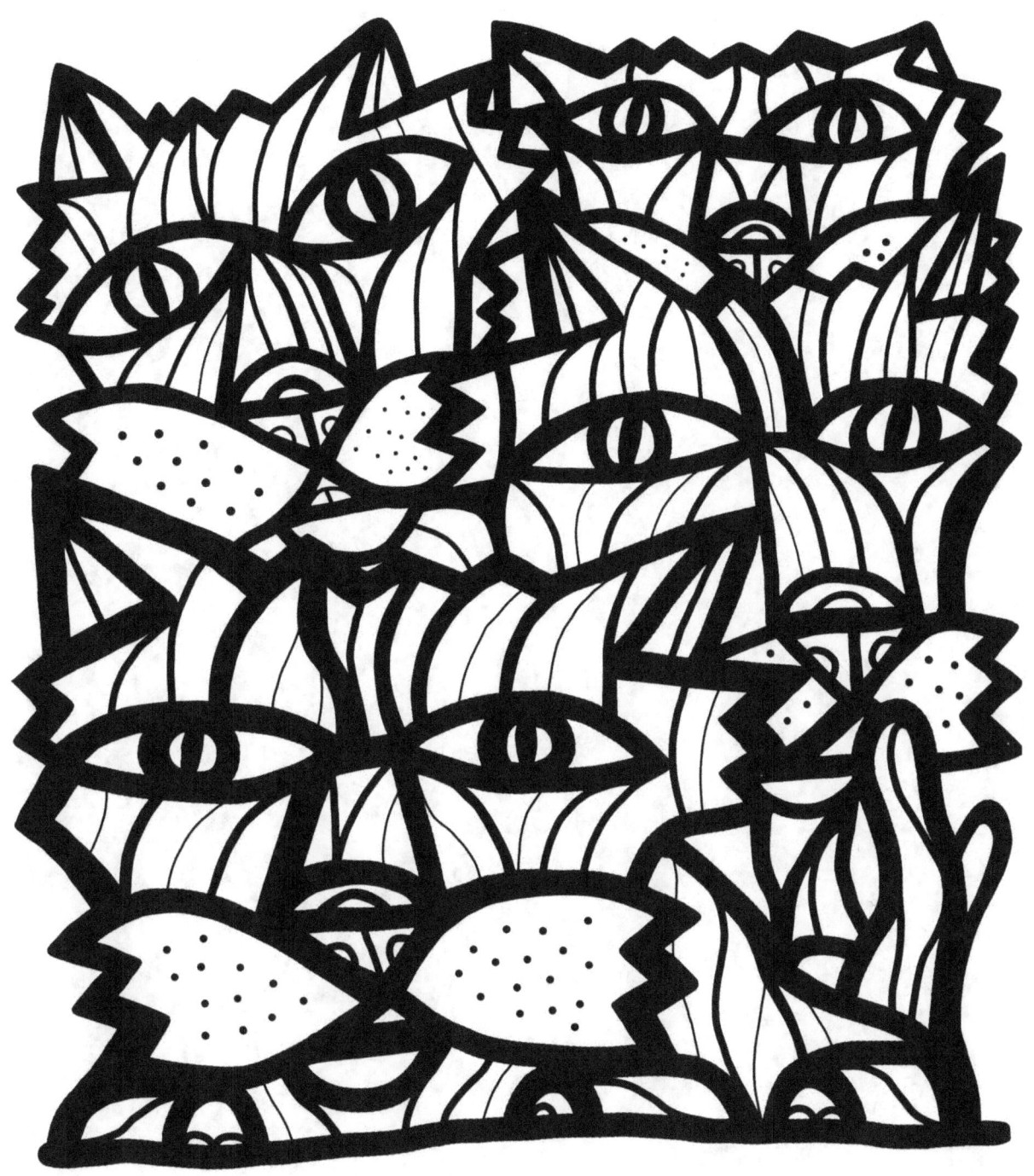

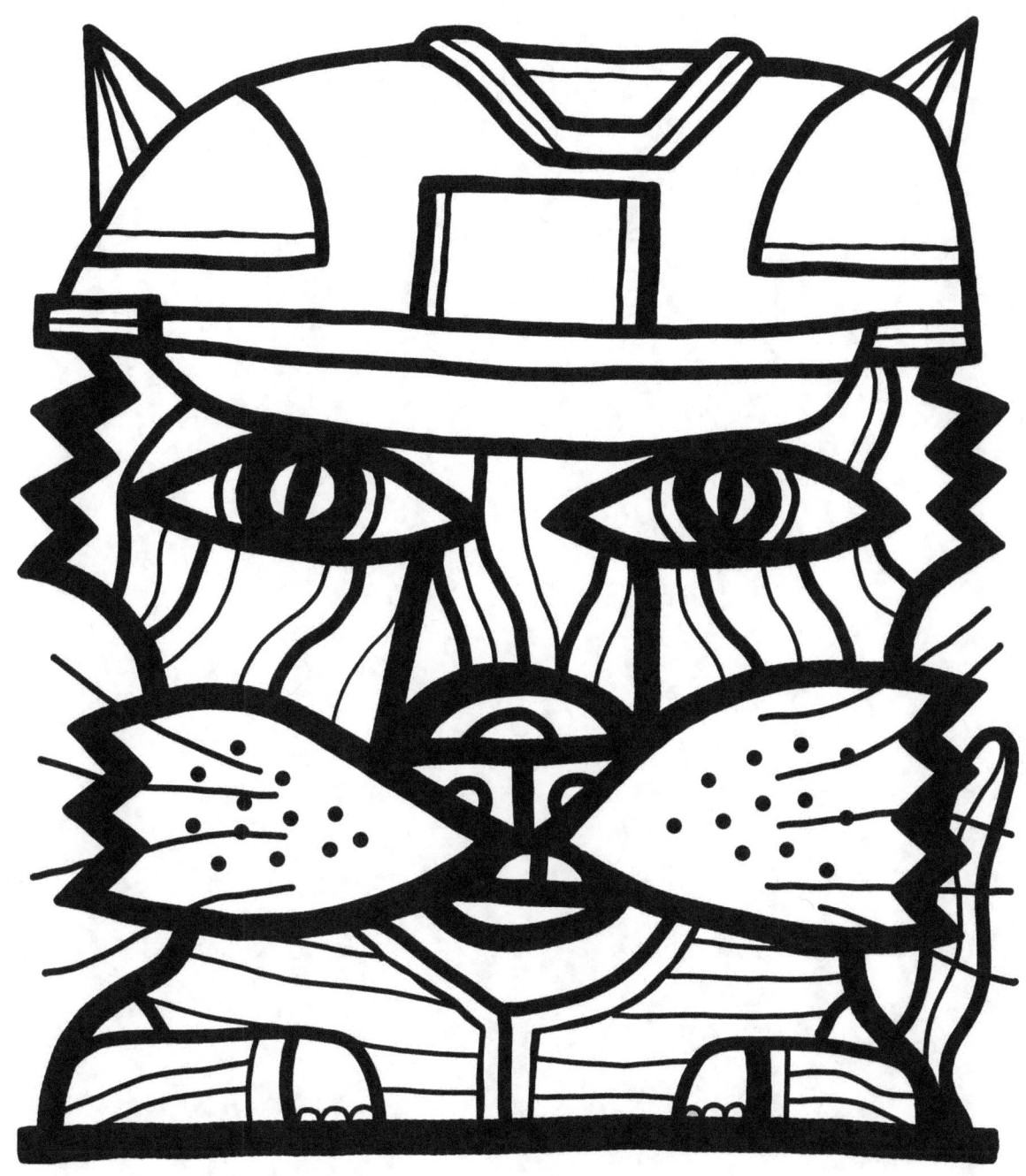

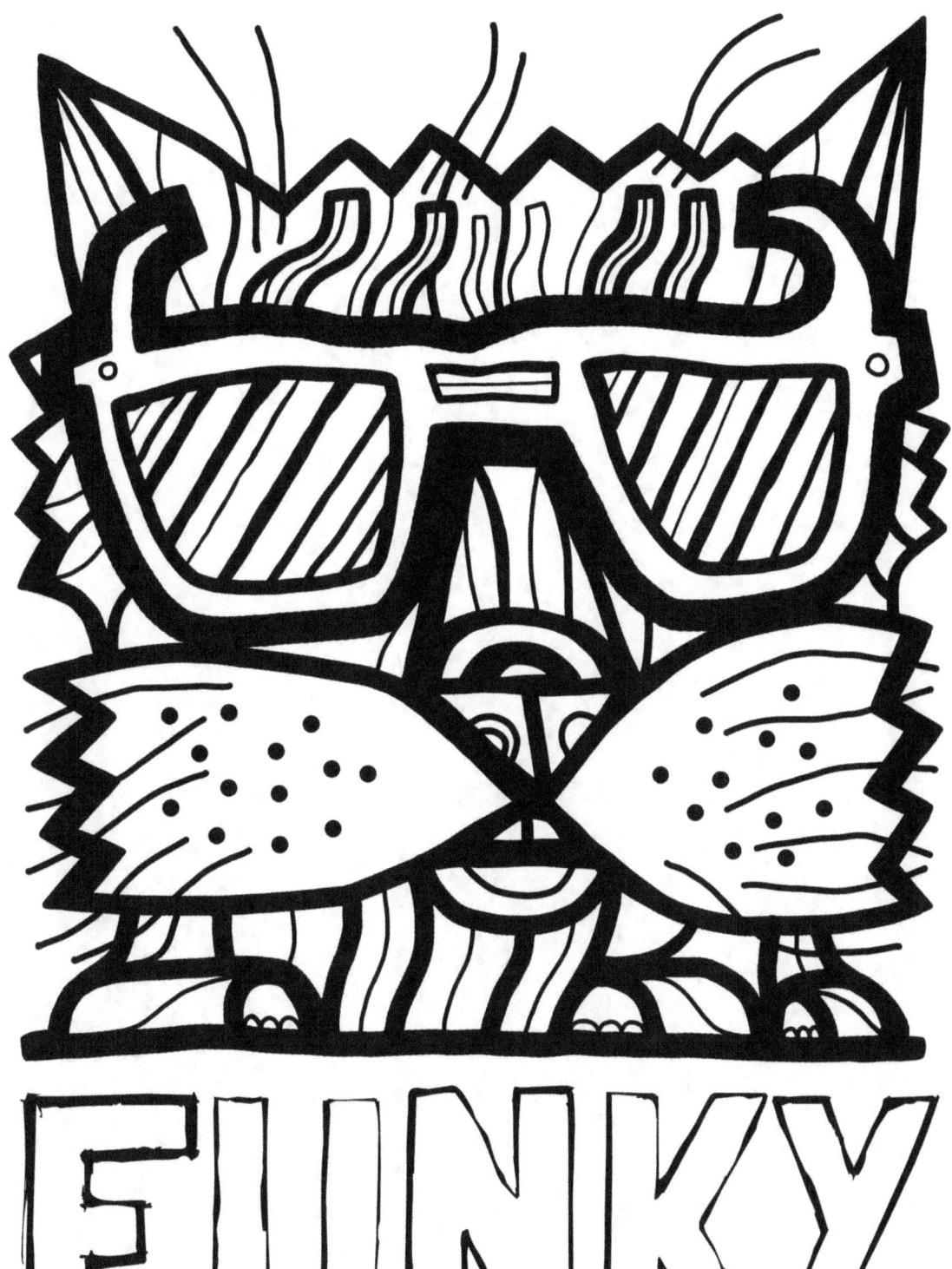

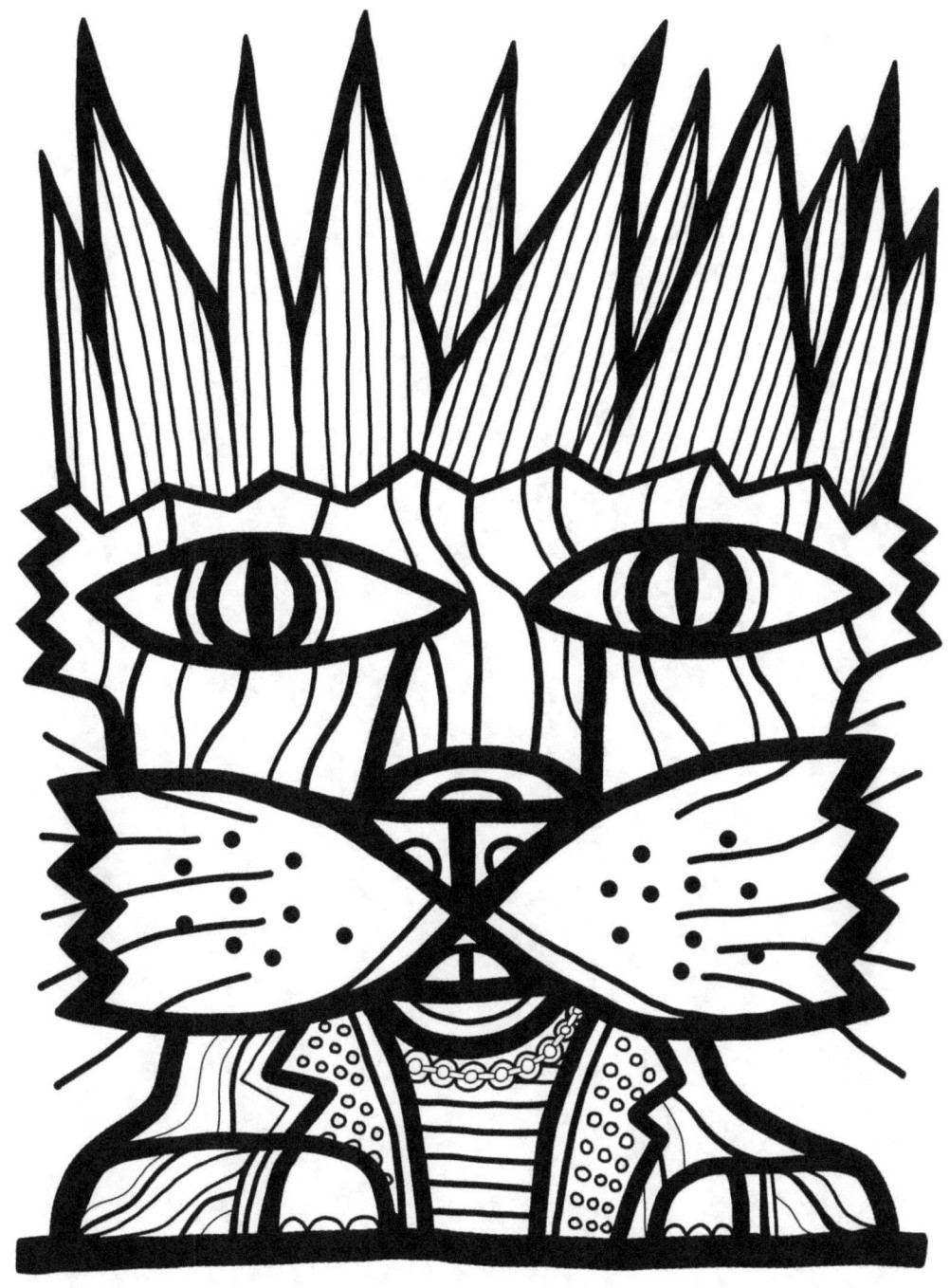

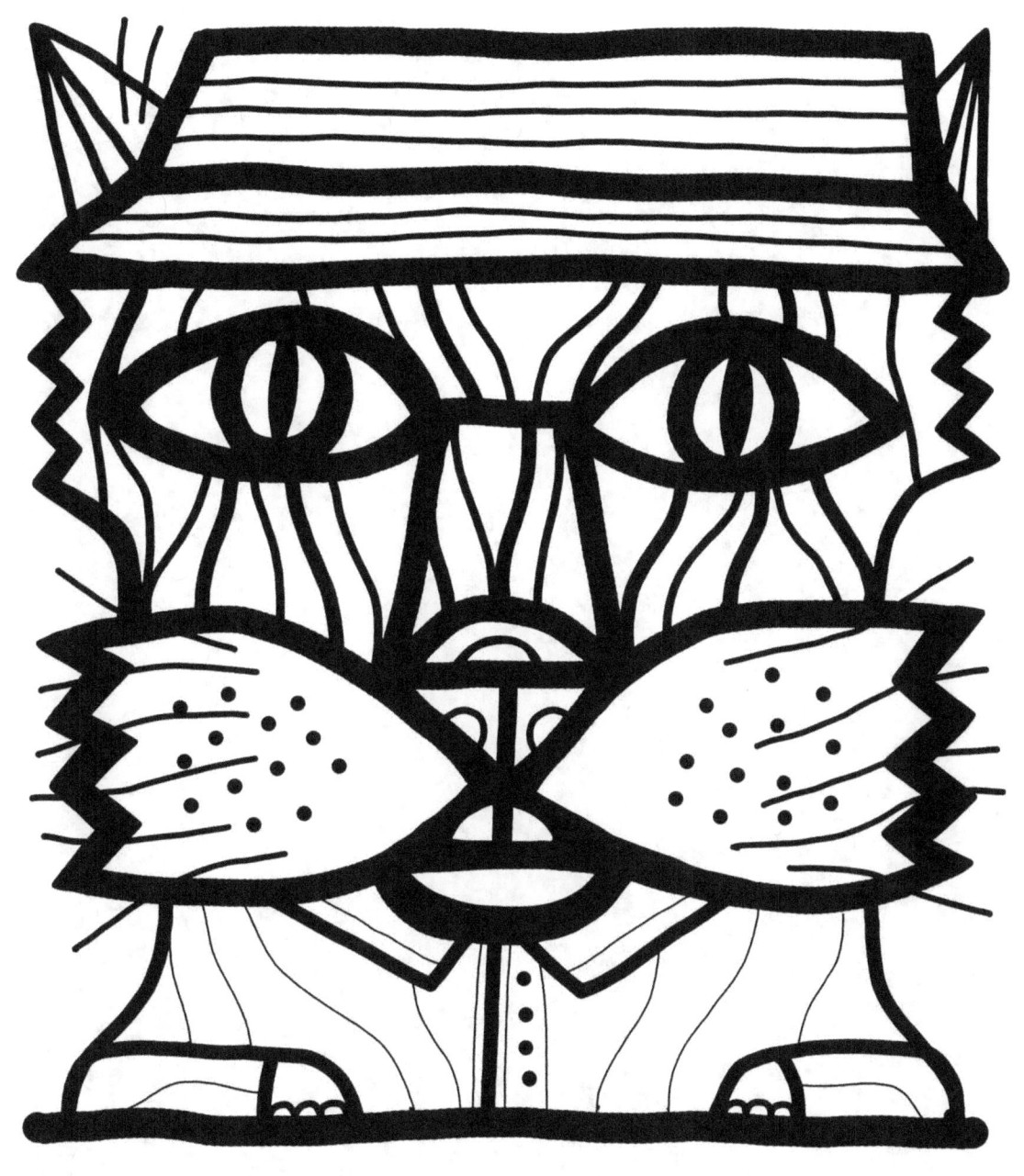

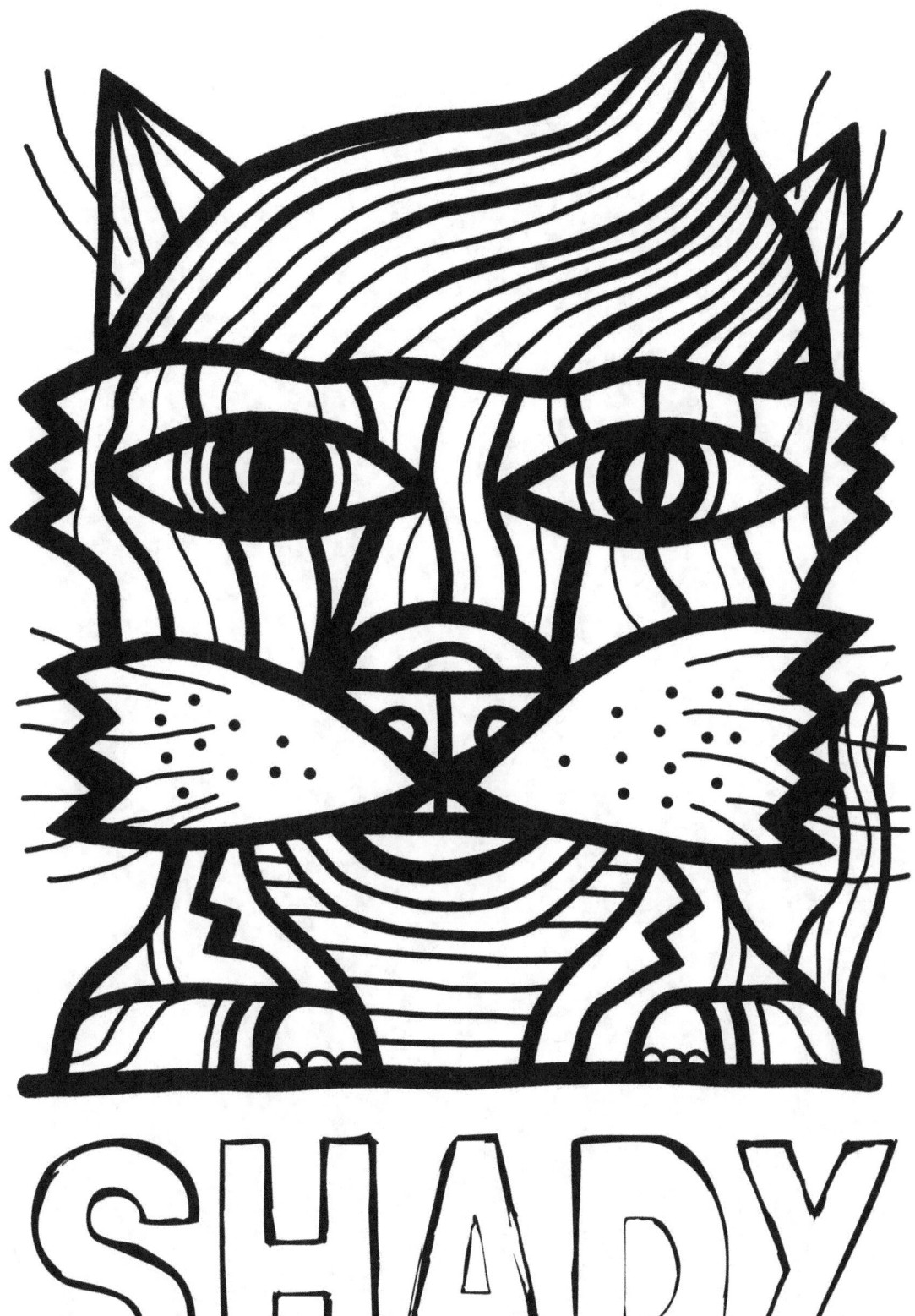

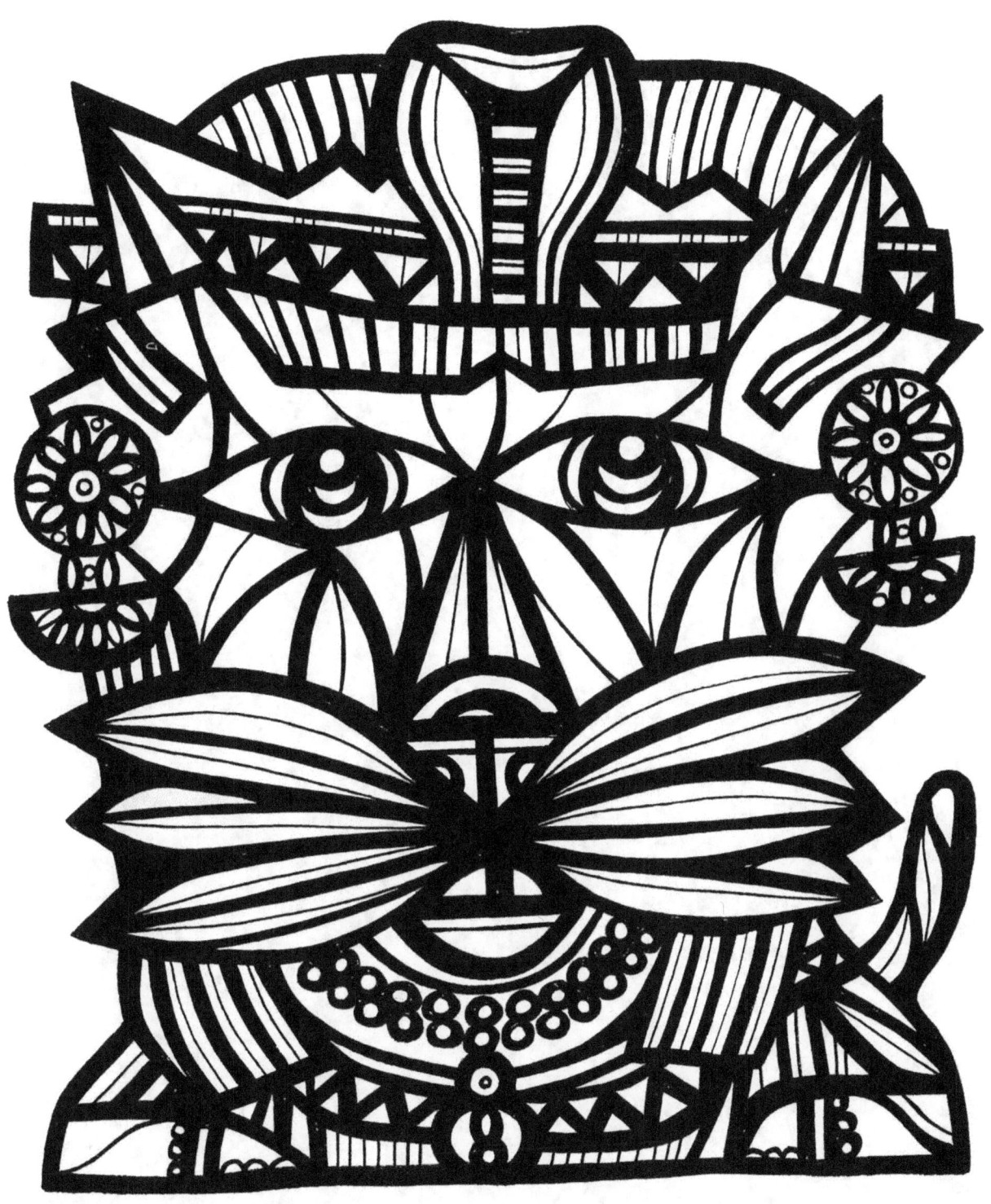

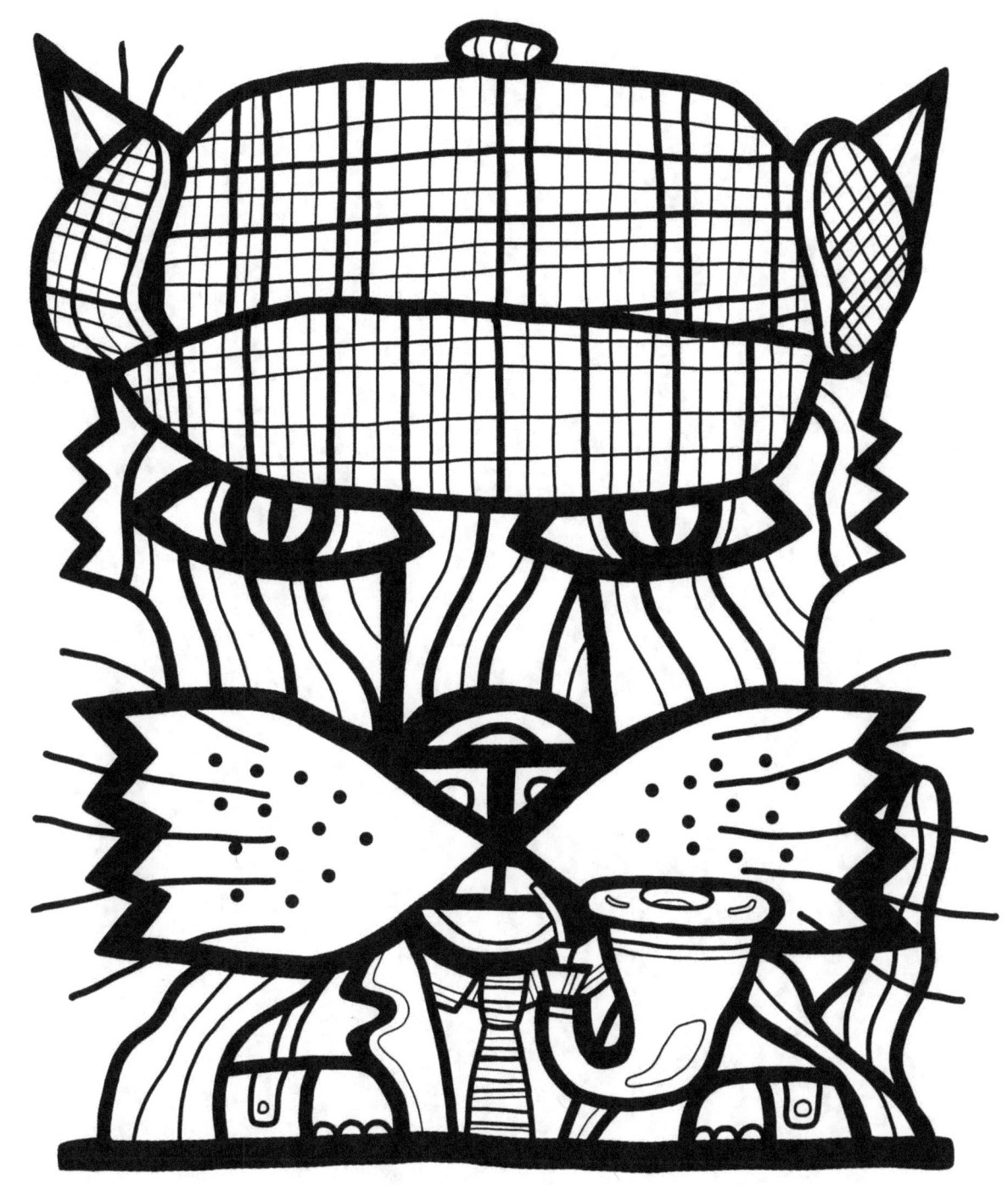

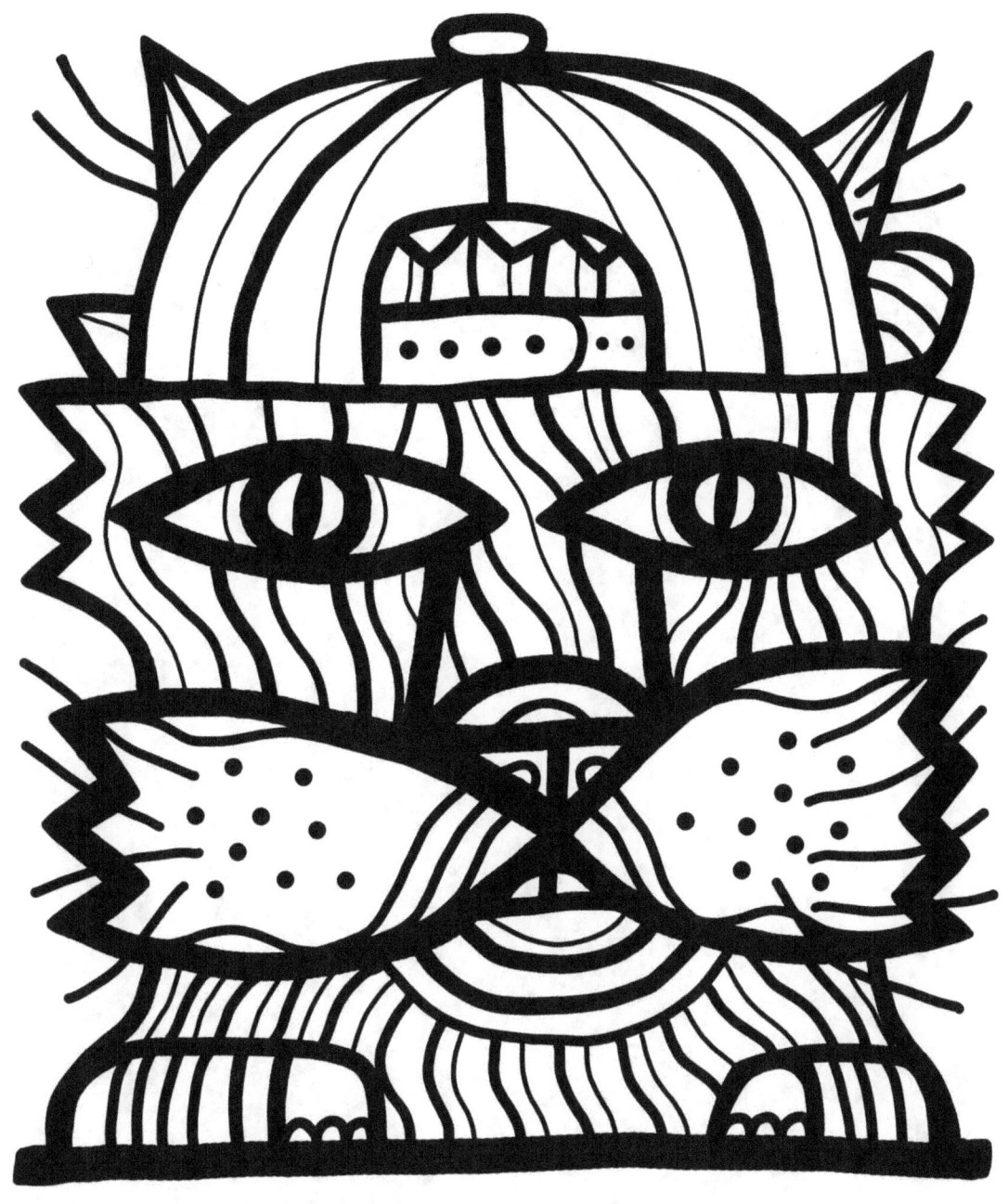

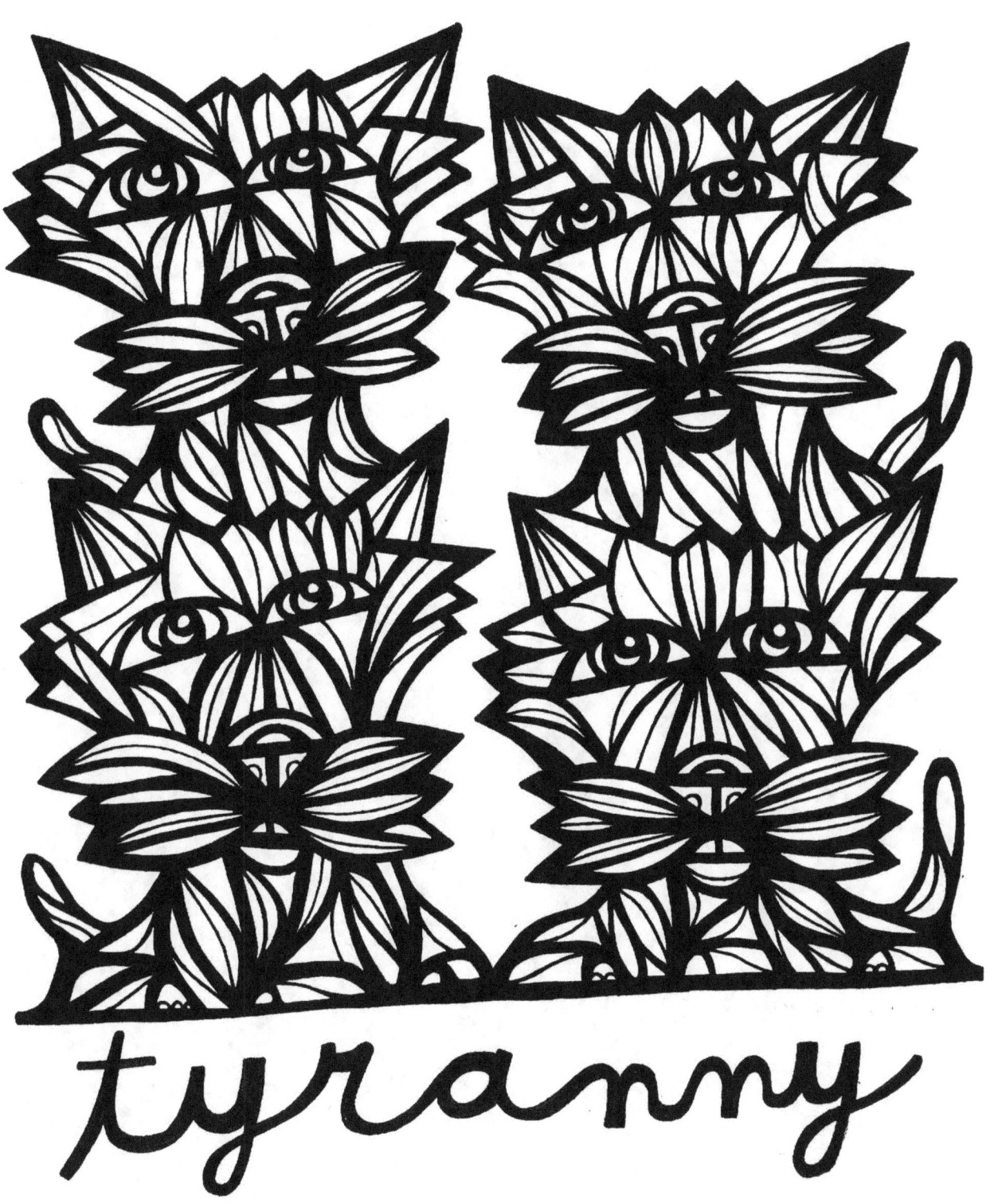

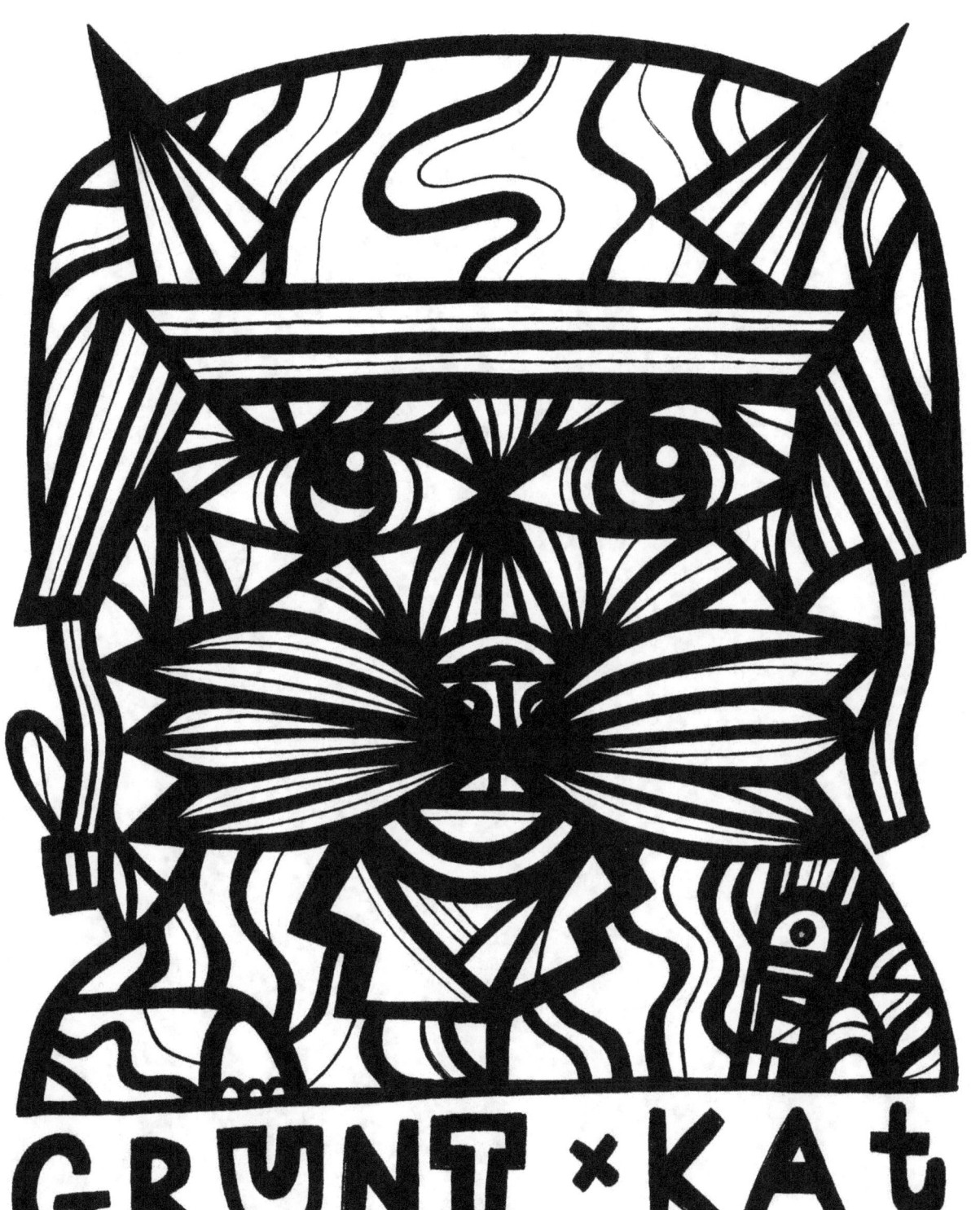

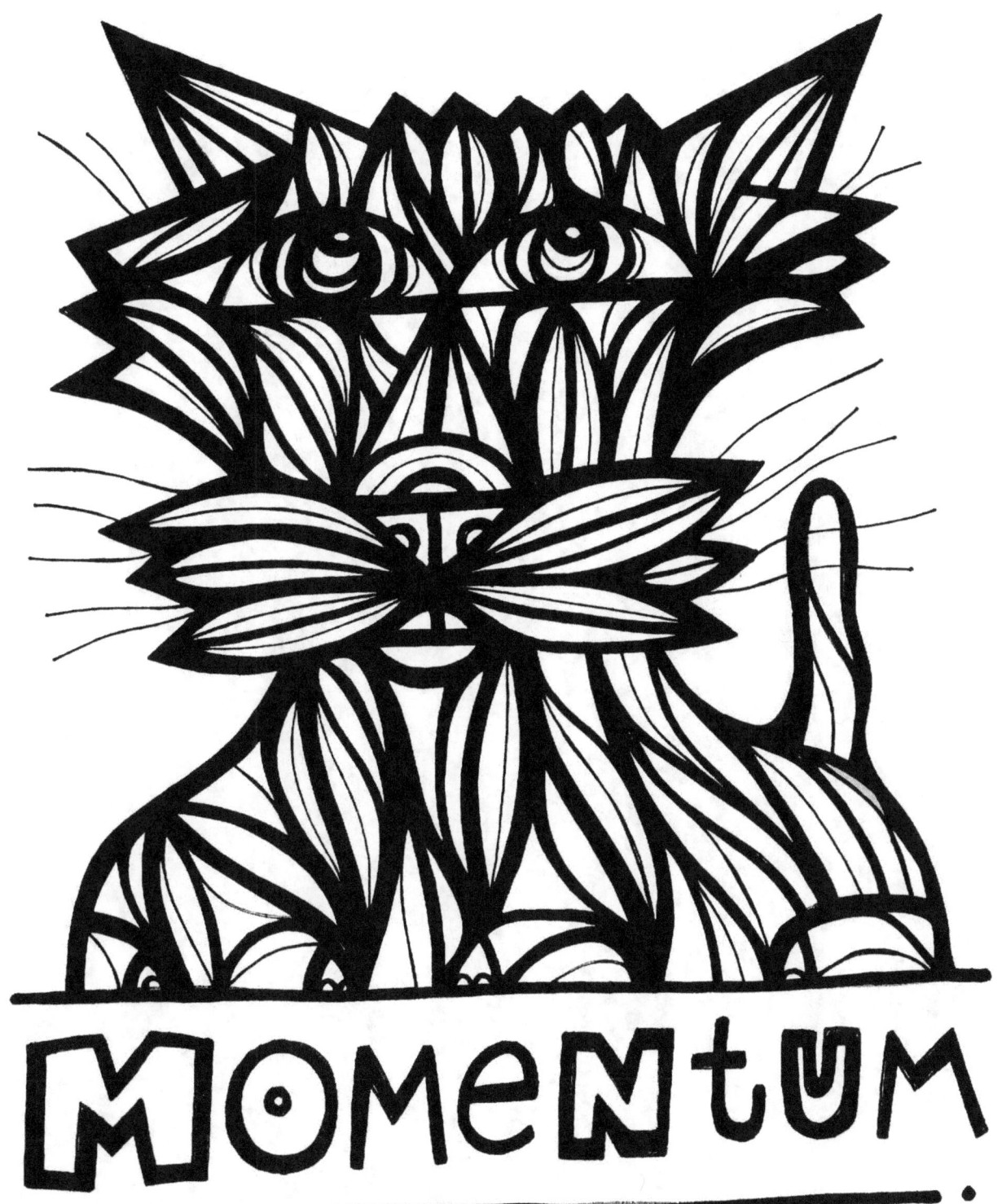

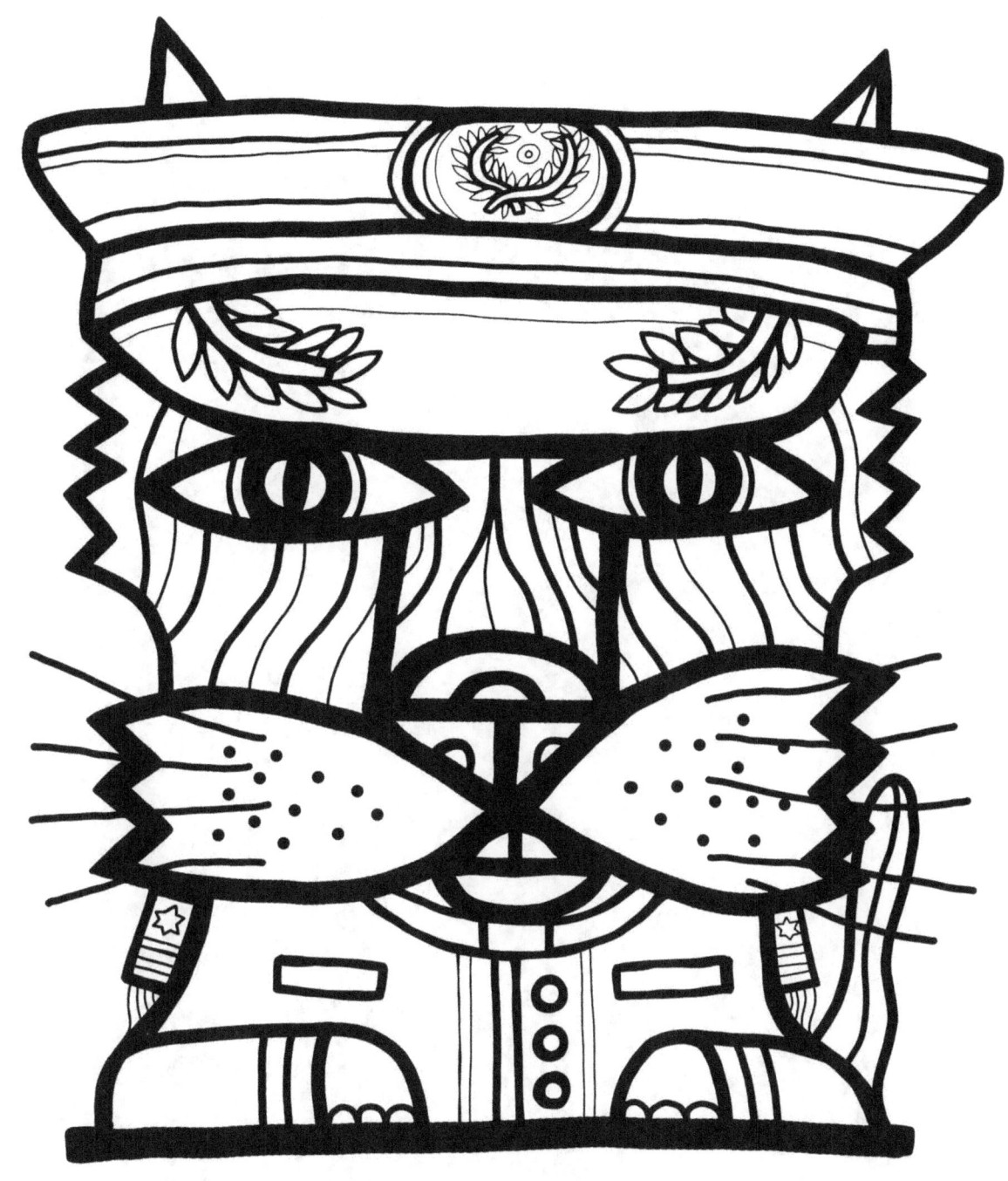

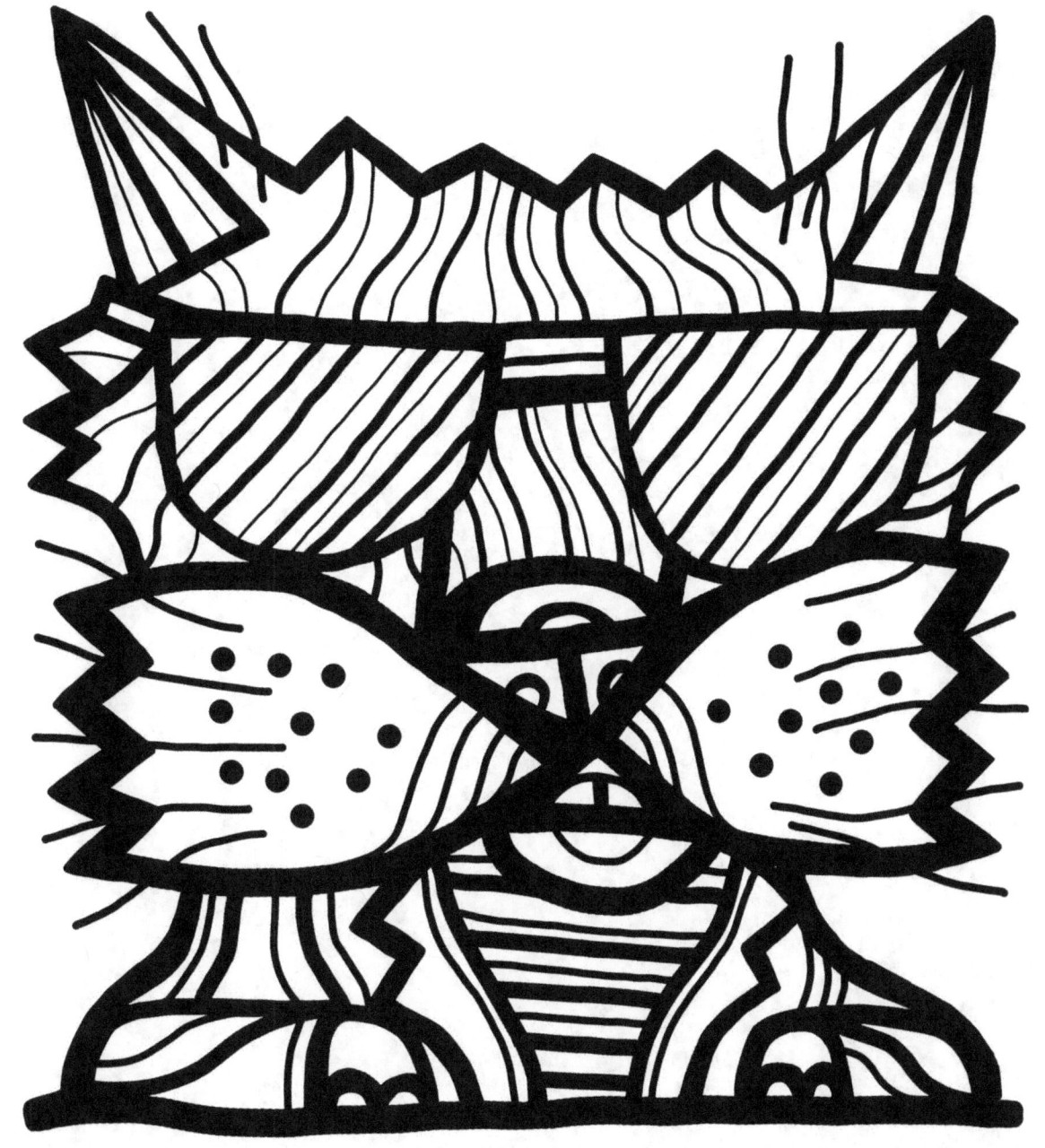

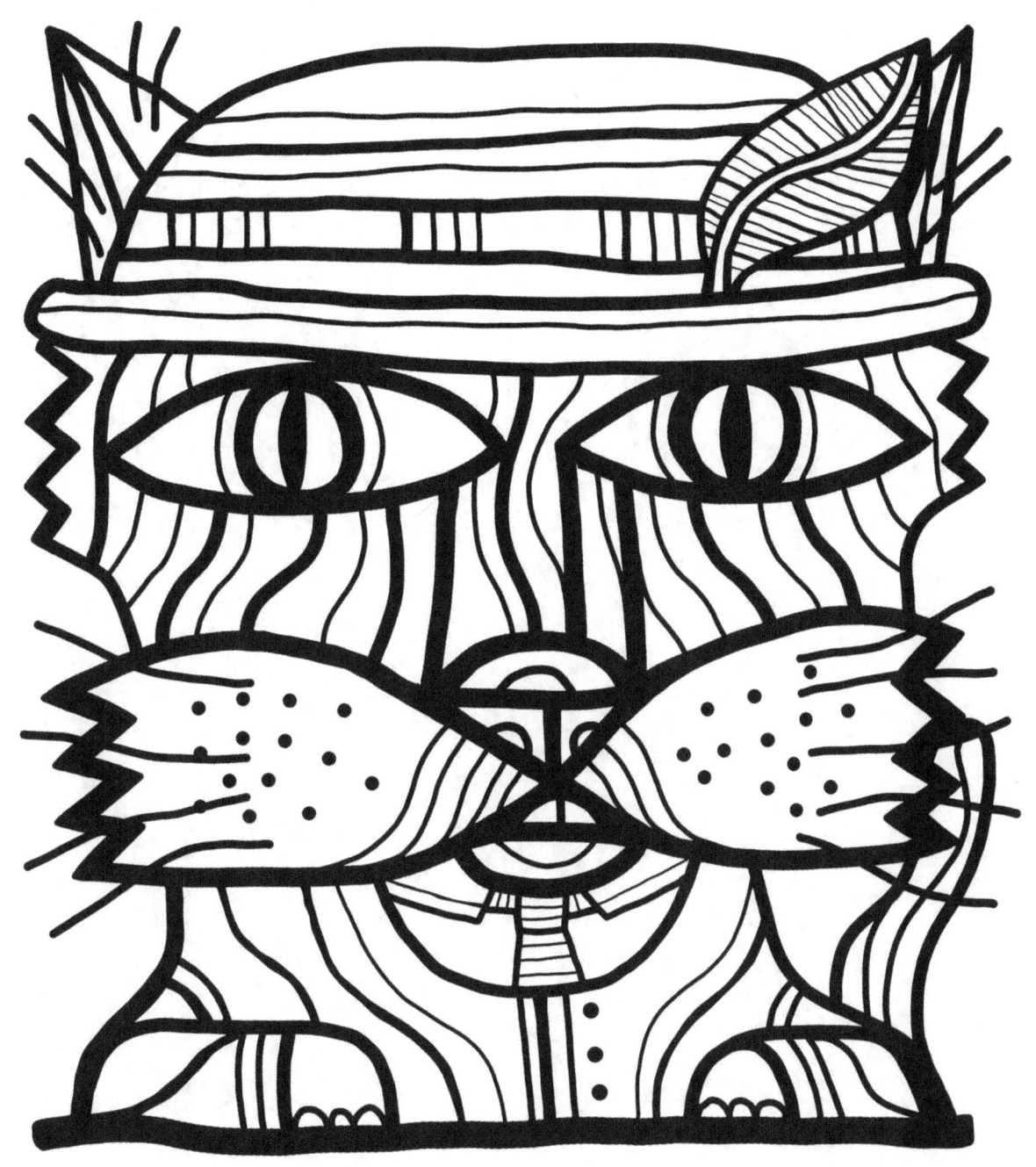

www.ingramcontent.com/pod-product-compliance
Lightning Source LLC
Chambersburg PA
CBHW082014230526
45468CB00022B/2265